HOW TO DRAW
MANGA

Maids & Miko

HOW TO DRAW MANGA: Maids & Miko
Joint publication by
Tatsuhiro Ozaki and Unkaku Koyama

Copyright © 2001 Tatsuhiro Ozaki
Copyright © 2001 Unkaku Koyama
Copyright © 2001 Graphic-sha Publishing Co., Ltd.

The book was first designed and produced by Graphic-sha Publishing Co., Ltd.
in Japan in 2001. This English edition was published by Graphic-sha Publishing Co., Ltd.
in Japan in 2002.

Graphic-sha Publishing Co., Ltd.
Sansou Kudan Bldg. 4th Floor
1-14-17 Kudan-kita, Chiyoda-ku, Tokyo 102-0073 Japan

Drawing, composition and scenario: Tatsuhiro Ozaki, Unkaku Koyama
Cover drawing and coloring: Ganma Suzuki
Main title logo design: Hideyuki Amemura
Japanese edition Editor: Motofumi Nakanishi (Graphic-sha Publishing Co., Ltd.)
English edition Editor: Glenn Kardy (JAPANIME Co., Ltd.)
Cover and text page layout: Shinichi Ishioka
English translaion management: Língua fránca, Inc. (an3y-skmt@asahi-net.or.jp)
Foreign language edition project coordinator: Kumiko Sakamoto (Graphic-sha Publishing Co., Ltd.)

All rights reserved. No part of this publication may be reproduced,
stored in a retrieval system, or transmitted in any form or by any means,
electronic, mechanical, photocopying, recording, or otherwise,
without the prior written permission of the publisher

Distributed by
Japanime Co., Ltd.
2-8-102 Naka-cho, Kawaguchi-shi,
Saitama 332-0022, Japan
Phone /Fax: +81-(0)48-259-3444
E-mail: sales@japanime.com
http:// www.japanime.com

First printing: September 2002

ISBN: 4-7661-1317-9
Printed and bound in China by Everbest Printing Co., Ltd.

Table of Contents

Foreword

This volume, written for manga artists of all skill levels, was compiled to serve as reference when drawing maid uniforms and the traditional dress of *miko* (pronounced mee-koh), young maidens in the service of Shinto shrines.

This publication includes not only the costumes worn by maids and *miko*, but also covers traditional Japanese dress, using shade and shadow, drawing creases, and other various topics essential to drawing costumes. We hope that you read and study this book thoroughly to improve your skills.

Reproduction of the samples provided herein is permitted. However, we ask that you try to incorporate your own touches rather than simply produce a faithful copy. Accordingly, we have included illustrations that even intermediate artists find difficult to produce, along with compositions that are drawn frequently. We have also provided numerous detailed explanations of the key points in drawing the garments appearing in each section.

To have a "knack for drawing" is to have the ability to observe a subject carefully and then accurately represent the subject in an illustration. Once you learn they key points of observation, you too will possess this "knack." These points are presented through the focused topic of maid and *miko* costumes. Of course, artistic talent and experience go hand in hand. Consequently, the more you practice, the better you will become. Believe this and make the best of this book.

Maids, Cooks, Governesses, etc.

An Introduction to Domestic Servants

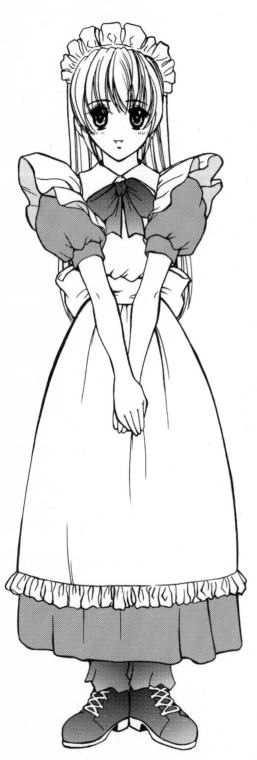

A domestic servant is one who works in another person's home, and is responsible for such things as the housework or the children's upbringing. In Japan, such employees were known as *kaseifu-san* or *otetsudai-san* (meaning "housekeeper" or "maid"). It is said these occupations claim a long tradition that can be traced back to the Assyrian Empire of the Near East (a collective term for the countries of Southwest Asia, primarily those on the Arabian Peninsula but including Egypt and others, and constituting one of the oldest civilizations in the world).

Even though with the advancements of the modern age a single homemaker is now able to handle all of these chores alone, there are likely many who, if given the financial means, would hire help to take care of the housework and children. Since up to only a few decades ago housework required considerable labor, it is only natural that such occupations would come into existence.

Today's familiar maid uniform originated in 19th-century Great Britain during the Industrial Revolution. At the time, Great Britain was a class-structured society, and those who employed domestic servants were members of the middle and upper classes. The number of domestic servants engaged by a given household depended on its economic status. In those cases where the household was able to hire only a single maid, that maid was expected to handle all of the housework. If the household was able to afford multiple servants, then the work would be divided among an assortment of domestic servants who were skilled in specific tasks.

The following is a sampling of domestic servants' roles.

Housemaid

The housemaid is likely the closest to what is associated with the word "maid" today. Her duties consisted primarily of chores within the home, such as making the beds, cleaning the house and looking after her employer.

Nursemaid

The children's nanny. Traditionally, middle- and upper-class homes had a nursery, and children were raised predominantly by a woman referred to as a "nurse" rather than by their mother. The nursemaid also was responsible for housekeeping in the nursery.

Cook

This job today is often held by men, but the word itself is gender-free. The cook was skilled in the culinary arts and ran the kitchen.

Kitchenmaid

The kitchenmaid served as assistant to the cook. A hierarchy would form in households where more than one kitchenmaid was employed, resulting in a structure quite similar to the kitchen of a modern restaurant.

Scullery maid

The scullery maid had the lowest position in the kitchen and was delegated primarily the position of washing dishes. A scullery was a small room adjacent to the kitchen where ingredients were prepared and dishes were washed before being sent to the kitchen.

Stillroom maid

Stillroom maids were responsible for preparing the coffee or tea, and making and storing biscuits, cakes, jams and preserves, liqueurs, etc. The stillroom maid was a position shown greater importance once the British custom of serving tea, sandwiches and cakes as an afternoon meal became established. The stillroom was a room equipped and used for distilling or preparing medicines and herbal concoctions, fragrances, preserves and cakes. With advancements in medicine, the household still fell out of use, but the name remains.

Laundress

The laundress was primarily responsible for the laundry, which was an onerous task way back in the days before washing machines were invented.

Parlormaid

The parlormaid was in charge of the linen and utensils for the table, and for preparing and serving wine and other drinks.

Housekeeper

The housekeeper was responsible for all of the lower female servants. The lady's maid, (who, like the housekeeper, was an upper servant) did not answer to the housekeeper.

Governess

Primarily of middle-class origin herself, the governess functioned as tutor to the children of the household. At the time, it was thought virtuous for men to be industrious, while women were expected to spend their time being charming and graceful. The only respectable options available to women of middle class who were lacking in financial means were that of writer, teacher or governess. However, very few middle-class households could afford a governess, making competition among those vying for a single position quite strong.

Lady's maid

The role of a lady's maid was not to engage in housework but to stay by and assist her employer. A lady's maid was desired by women of the upper class as a symbol of their peerage. She was a luxury representing the wealth of the household.

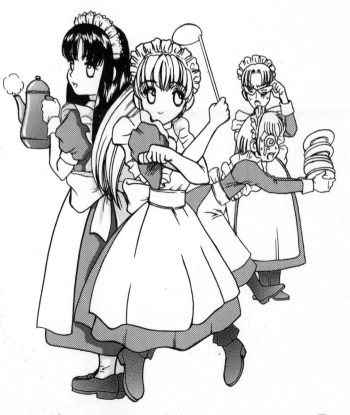

Frequently Drawn Maid Costumes

The most commonly drawn maid uniforms are billowy in appearance, owing to the presence of a pannier underneath to ensure that the external skirt has fullness and flounce. Traditionally, the pannier was made of a material called "tulle," a netted fabric about as stiff as a screen window. The parts that would touch the skin were made of sheer or soft materials. A soft petticoat was worn directly underneath the skirt to protect it from the stiff tulle.

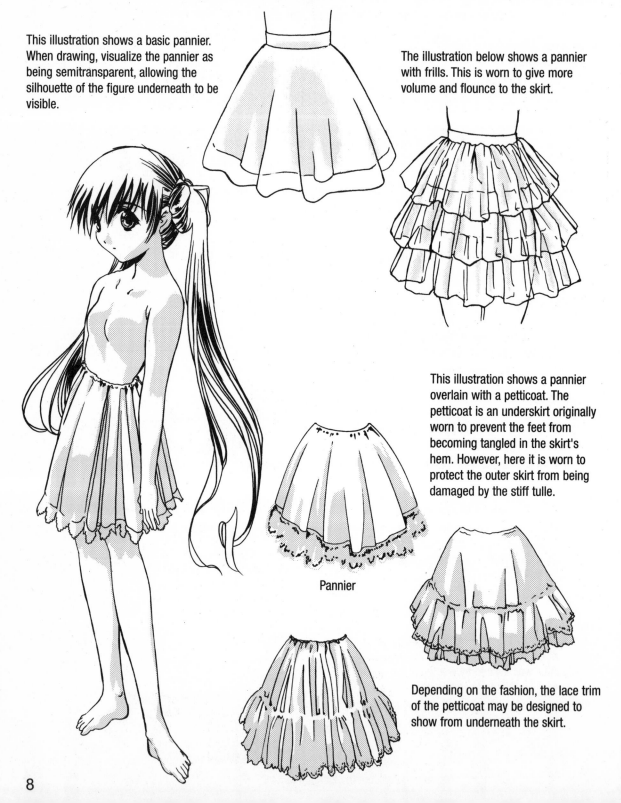

This illustration shows a basic pannier. When drawing, visualize the pannier as being semitransparent, allowing the silhouette of the figure underneath to be visible.

The illustration below shows a pannier with frills. This is worn to give more volume and flounce to the skirt.

This illustration shows a pannier overlain with a petticoat. The petticoat is an underskirt originally worn to prevent the feet from becoming tangled in the skirt's hem. However, here it is worn to protect the outer skirt from being damaged by the stiff tulle.

Pannier

Depending on the fashion, the lace trim of the petticoat may be designed to show from underneath the skirt.

Linen Headwear

Maids often wear linen headwear as part of their uniforms. Such headdresses come in various designs, ranging from a single simple band of ruffled fabric to complex multiple layers of lace.

The character in this example is wearing a headdress featuring a single yet ornate layer of lace. Similar designs with two or three layers of lace are also popular.

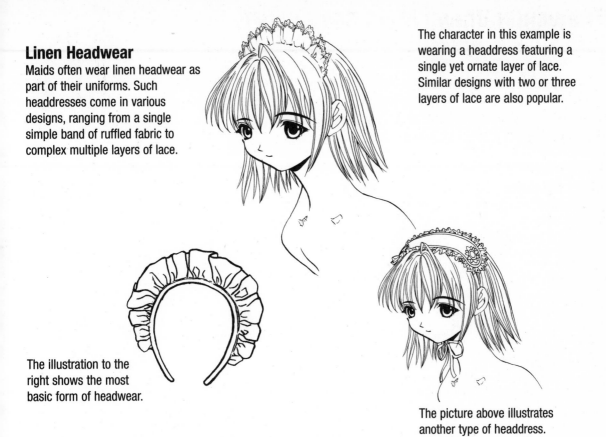

The illustration to the right shows the most basic form of headwear.

The picture above illustrates another type of headdress.

Bows

There are decorative bows that are already looped and can simply be attached to the garment. Figure A depicts the kind of bow that one might find on an apron. The bow in Figure B is for decorative purposes. Please note that the bow pictured in Figure B is rather one-dimensional, and therefore unsuitable for close-ups. When you want to draw attention to a bow, be sure to evoke a sense of volume as depicted in Figure A.

Figure A

The area indicated by the arrow is where creases are naturally in abundance. However, drawing all of those creases makes for an unattractive bow, so include just one, two or three lines at the most.

Figure B

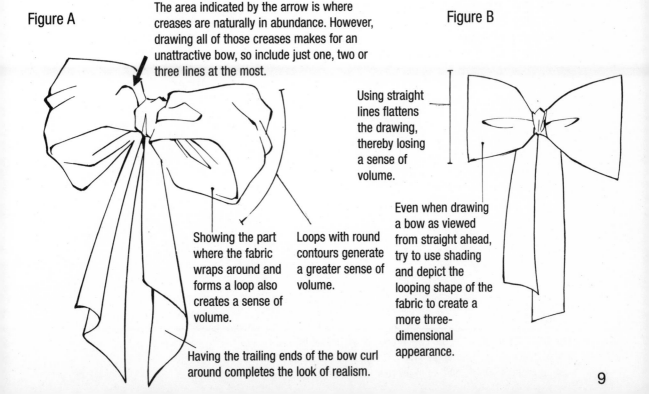

Using straight lines flattens the drawing, thereby losing a sense of volume.

Showing the part where the fabric wraps around and forms a loop also creates a sense of volume.

Loops with round contours generate a greater sense of volume.

Even when drawing a bow as viewed from straight ahead, try to use shading and depict the looping shape of the fabric to create a more three-dimensional appearance.

Having the trailing ends of the bow curl around completes the look of realism.

Drawing Ruffles

①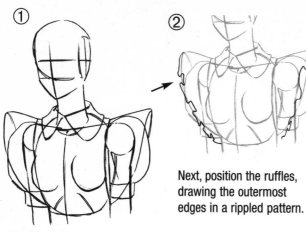

②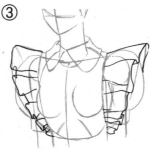

Next, position the ruffles, drawing the outermost edges in a rippled pattern.

Follow these simple steps. First, lay out the general form in a balanced composition.

③

Add lines representing the small folds (called gathers) that extend from the rippled edges to the center.

④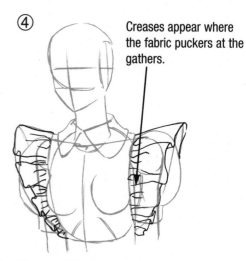

Creases appear where the fabric puckers at the gathers.

Finally, add the inside line of the gathers.

Structure of a Ruffle

Pulling a thread on one side of a fabric and causing it to ruffle is called "drawing a gather." Gathers scrunch the fabric, creating ruffles and frills. Puckering forms at the gather. One point requiring attention when drawing ruffles is to keep them varied. Remember, you are not drawing a repeated pattern. Alternate and merge together various rhomboid, square, triangular and round forms to create a satisfying image of ruffles and frills.

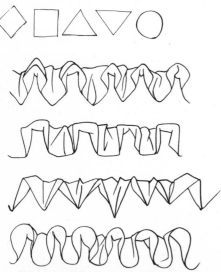

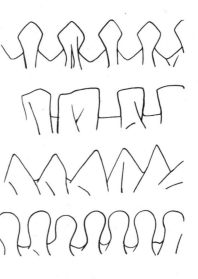

Note that when in a circle, the appearance of individual frills changes according to the angle. Use this figure as reference when drawing each frill and ruffle on your maid's uniform.

Standing

The following pages present a character in the standing position wearing a variety of maid uniforms.

The uniform appearing on this page is very popular and is reminiscent of the clothing worn by Alice in Wonderland. The sleeves are puffed. The apron has a bib, and ruffles appear on the shoulders.

This is a full, flared skirt that billows with a pannier underneath.

An axial line

The character takes on a more charming appearance when drawn with an axial line that has a slight S-curve.

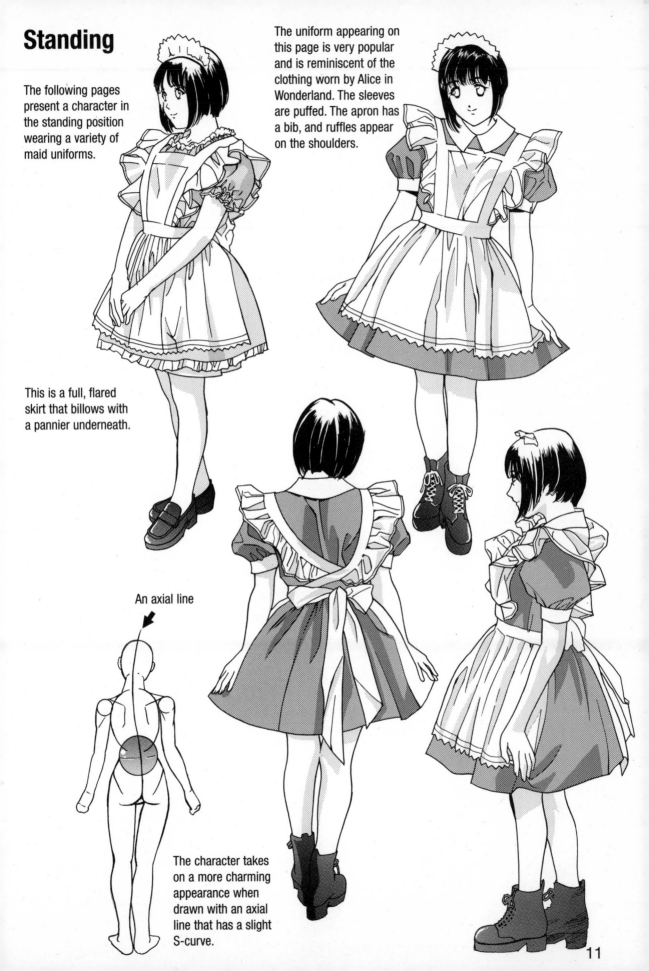

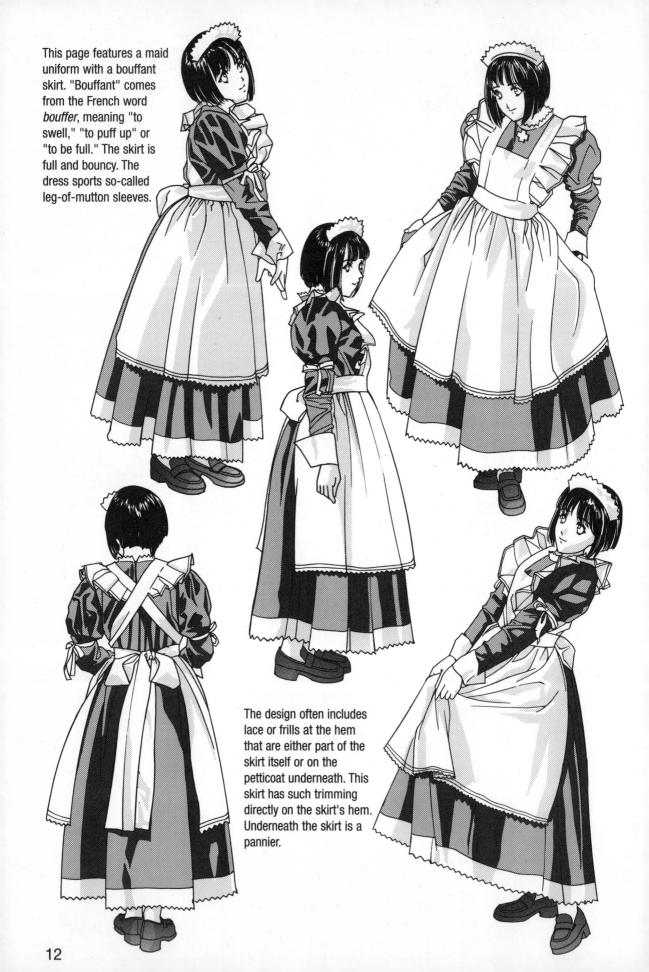

This page features a maid uniform with a bouffant skirt. "Bouffant" comes from the French word *bouffer*, meaning "to swell," "to puff up" or "to be full." The skirt is full and bouncy. The dress sports so-called leg-of-mutton sleeves.

The design often includes lace or frills at the hem that are either part of the skirt itself or on the petticoat underneath. This skirt has such trimming directly on the skirt's hem. Underneath the skirt is a pannier.

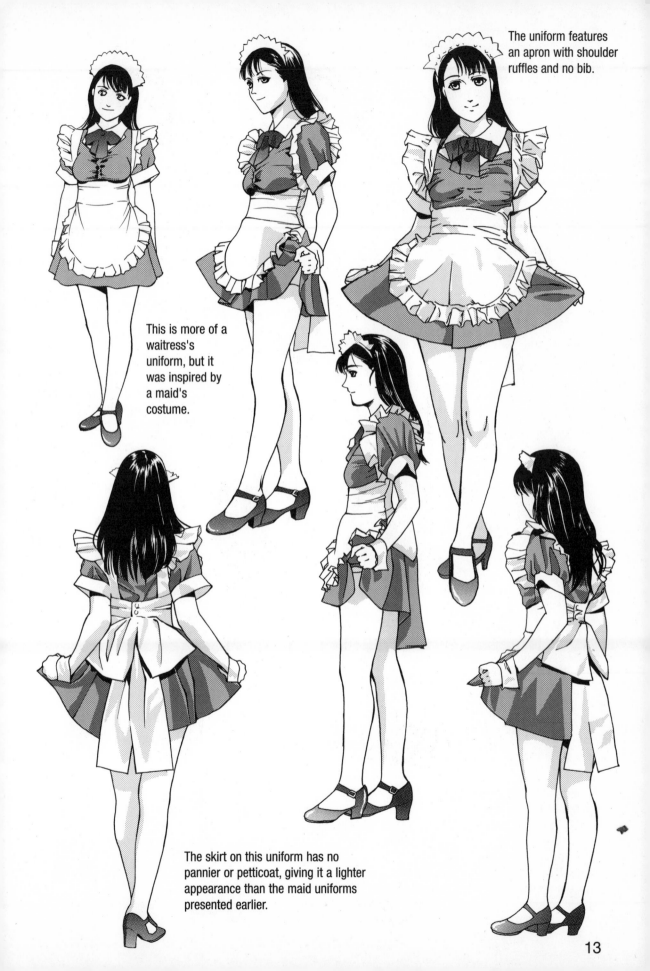

The uniform features an apron with shoulder ruffles and no bib.

This is more of a waitress's uniform, but it was inspired by a maid's costume.

The skirt on this uniform has no pannier or petticoat, giving it a lighter appearance than the maid uniforms presented earlier.

13

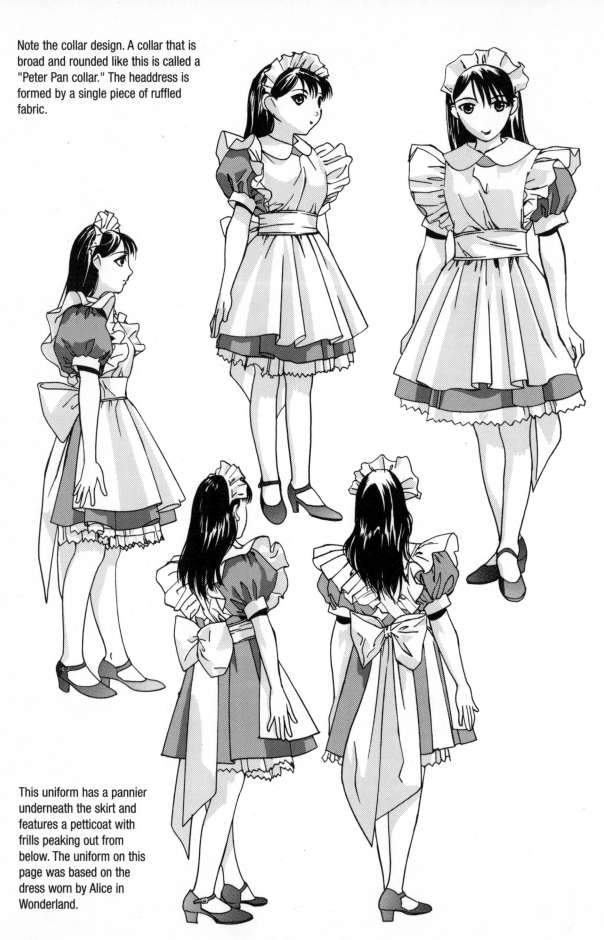

Note the collar design. A collar that is broad and rounded like this is called a "Peter Pan collar." The headdress is formed by a single piece of ruffled fabric.

This uniform has a pannier underneath the skirt and features a petticoat with frills peaking out from below. The uniform on this page was based on the dress worn by Alice in Wonderland.

Undergarments

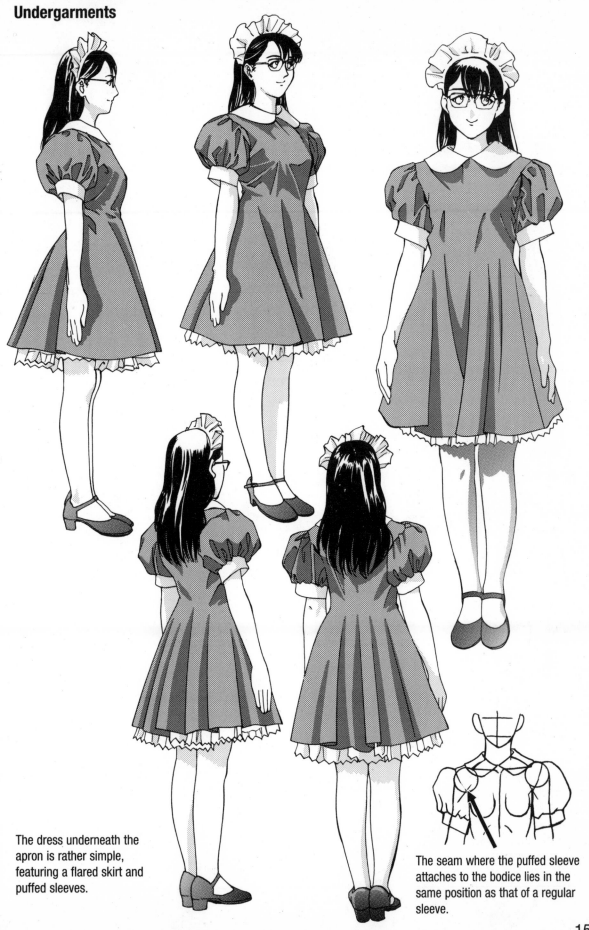

The dress underneath the apron is rather simple, featuring a flared skirt and puffed sleeves.

The seam where the puffed sleeve attaches to the bodice lies in the same position as that of a regular sleeve.

Bowing

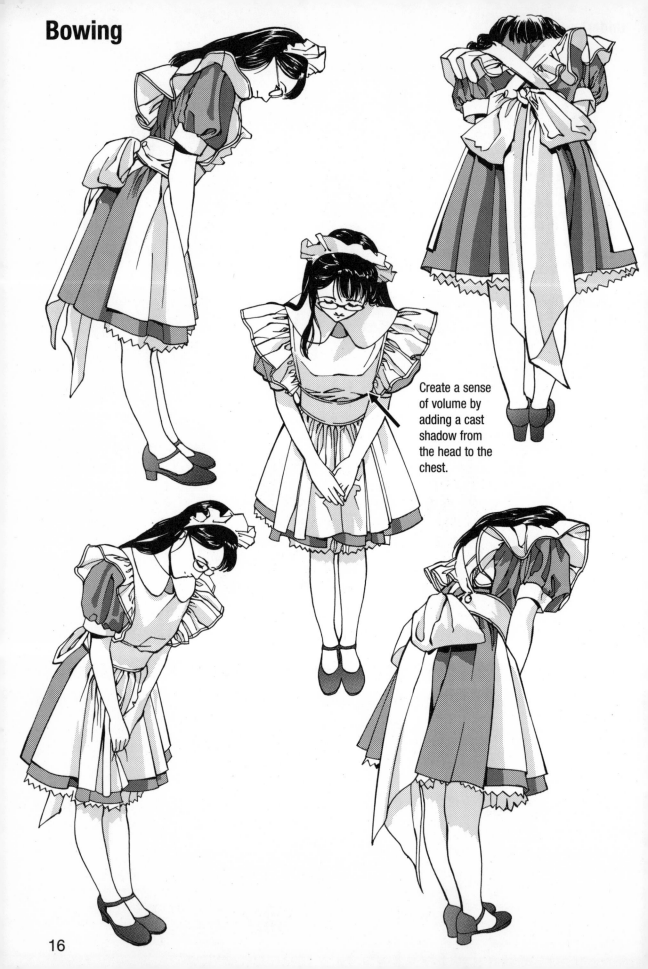

Create a sense of volume by adding a cast shadow from the head to the chest.

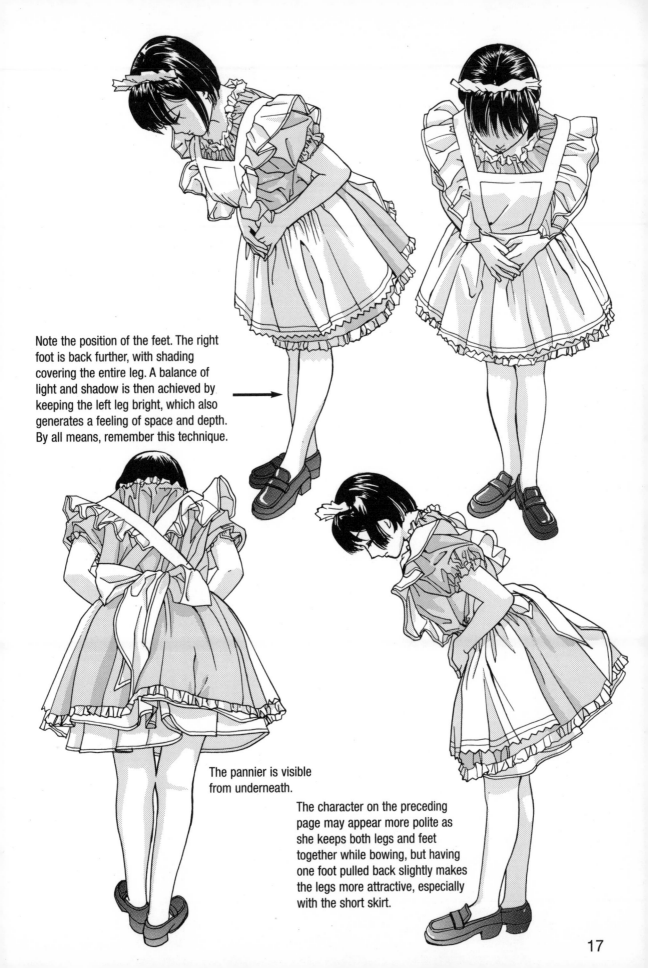

Note the position of the feet. The right foot is back further, with shading covering the entire leg. A balance of light and shadow is then achieved by keeping the left leg bright, which also generates a feeling of space and depth. By all means, remember this technique.

The pannier is visible from underneath.

The character on the preceding page may appear more polite as she keeps both legs and feet together while bowing, but having one foot pulled back slightly makes the legs more attractive, especially with the short skirt.

17

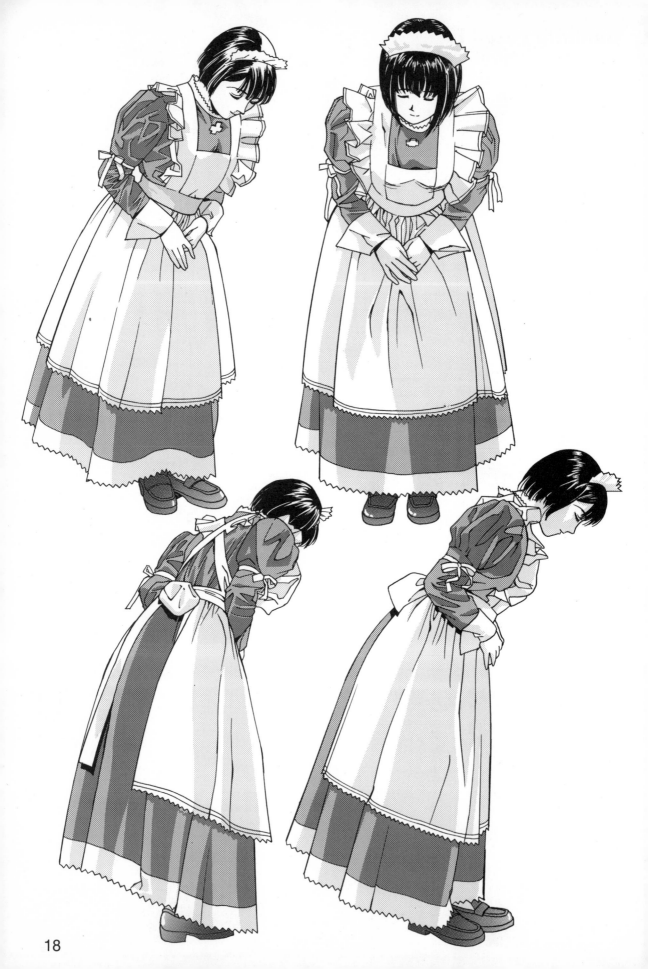

Bending Forward

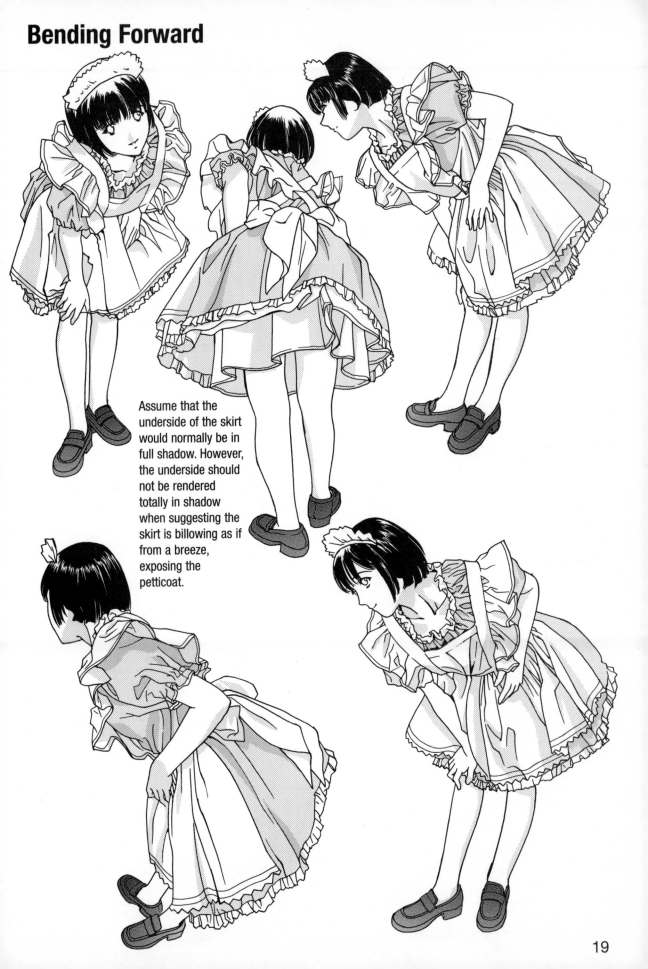

Assume that the underside of the skirt would normally be in full shadow. However, the underside should not be rendered totally in shadow when suggesting the skirt is billowing as if from a breeze, exposing the petticoat.

19

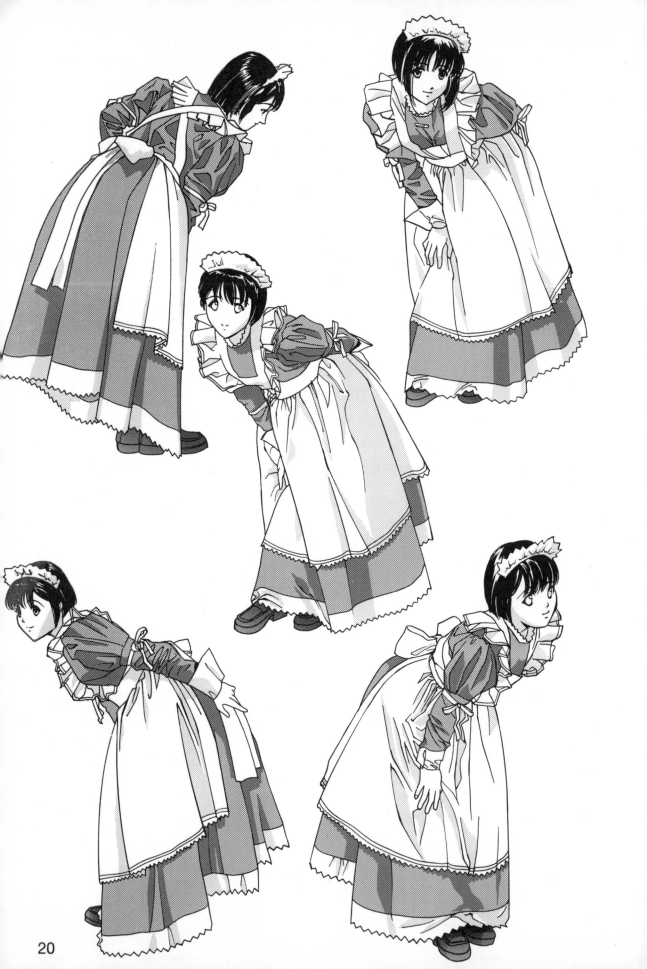

Looking Back

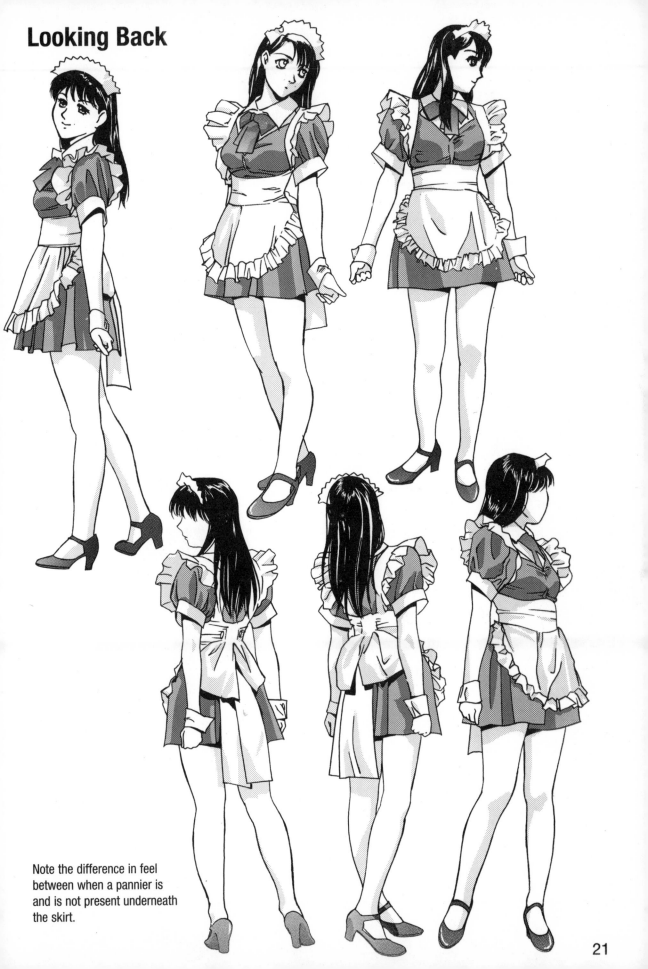

Note the difference in feel between when a pannier is and is not present underneath the skirt.

Draw large and dramatic
ripples in the skirt and ruffles.

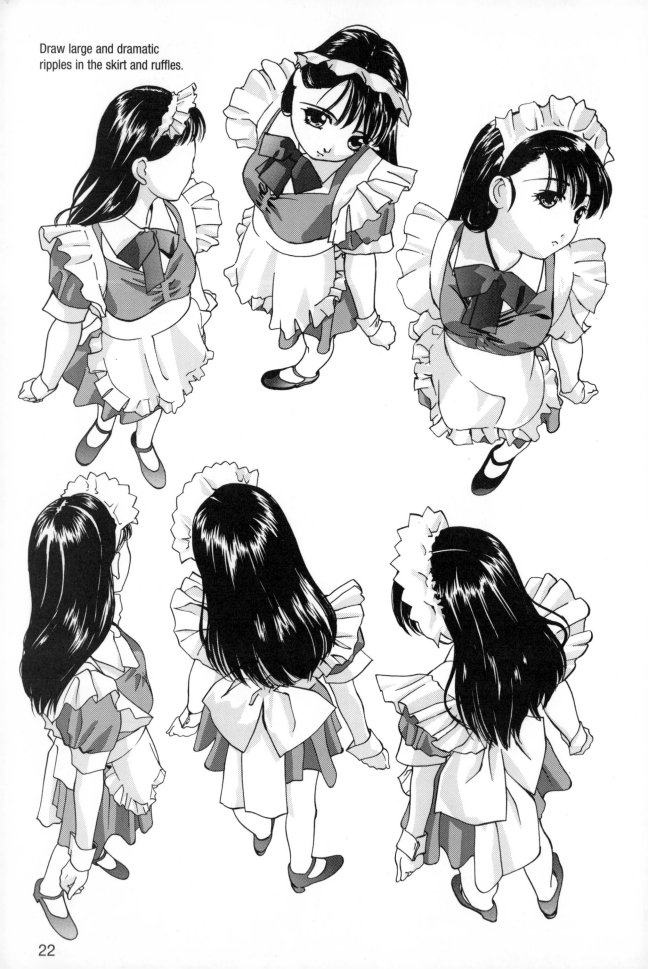

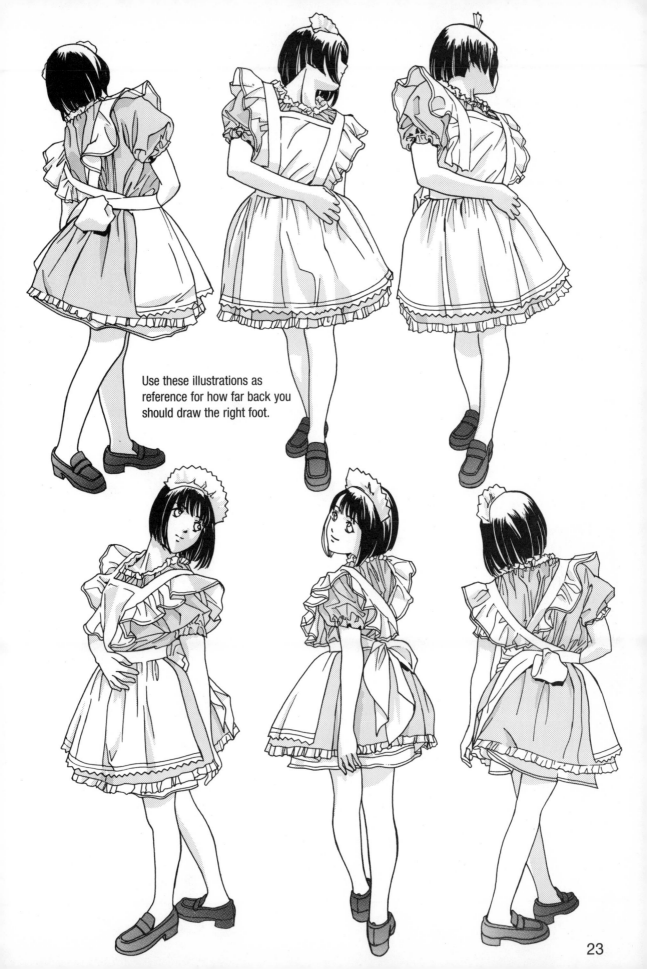

Use these illustrations as reference for how far back you should draw the right foot.

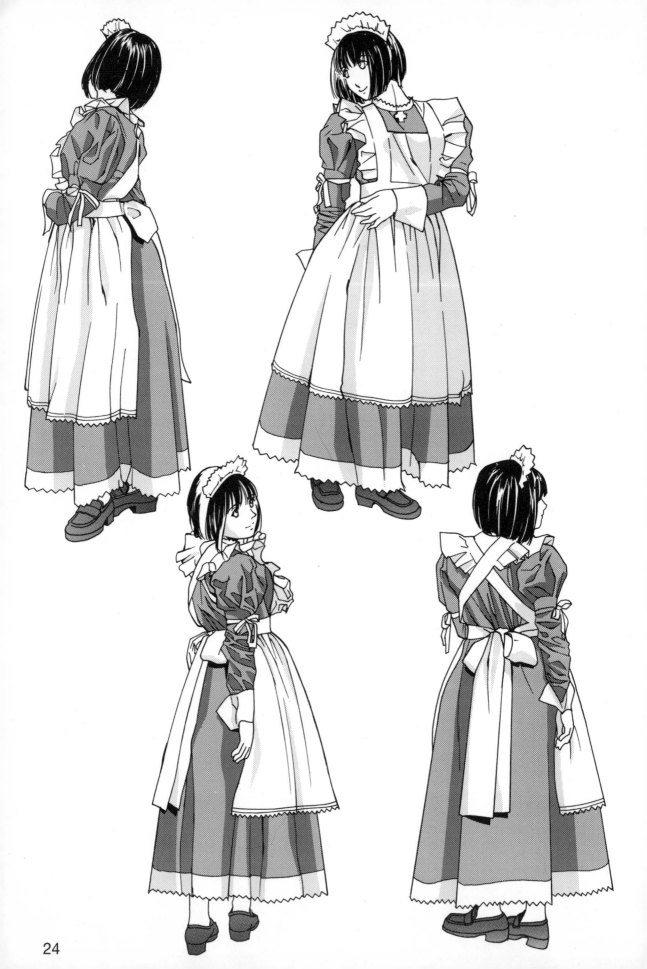

Both Arms Raised Forward

Note changes in the fabric around the shoulders and the presence of creases when both arms are raised.

These illustrations show how creases appear in the dress underneath the apron.

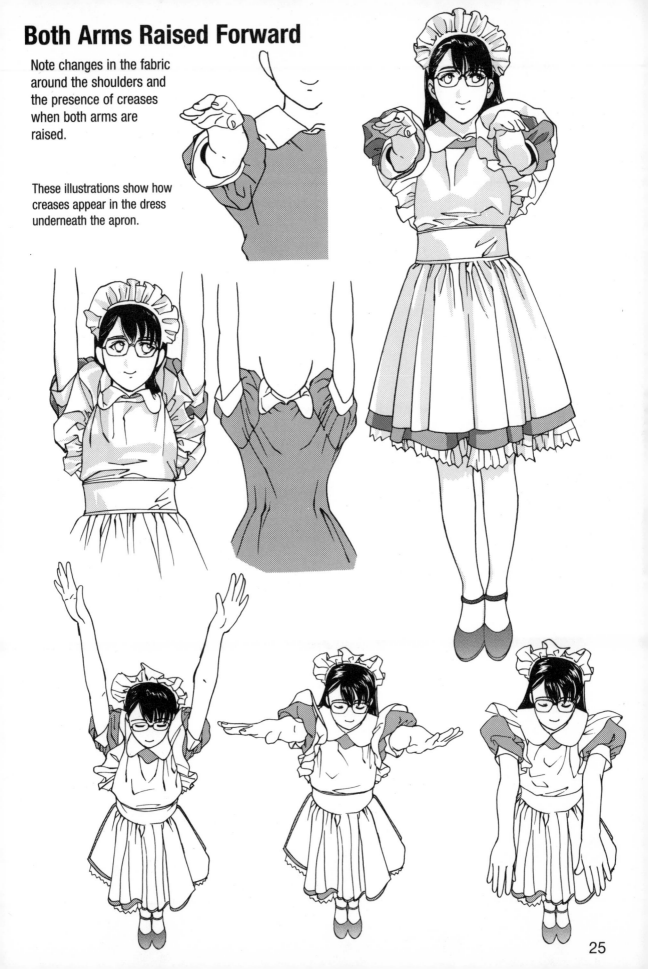

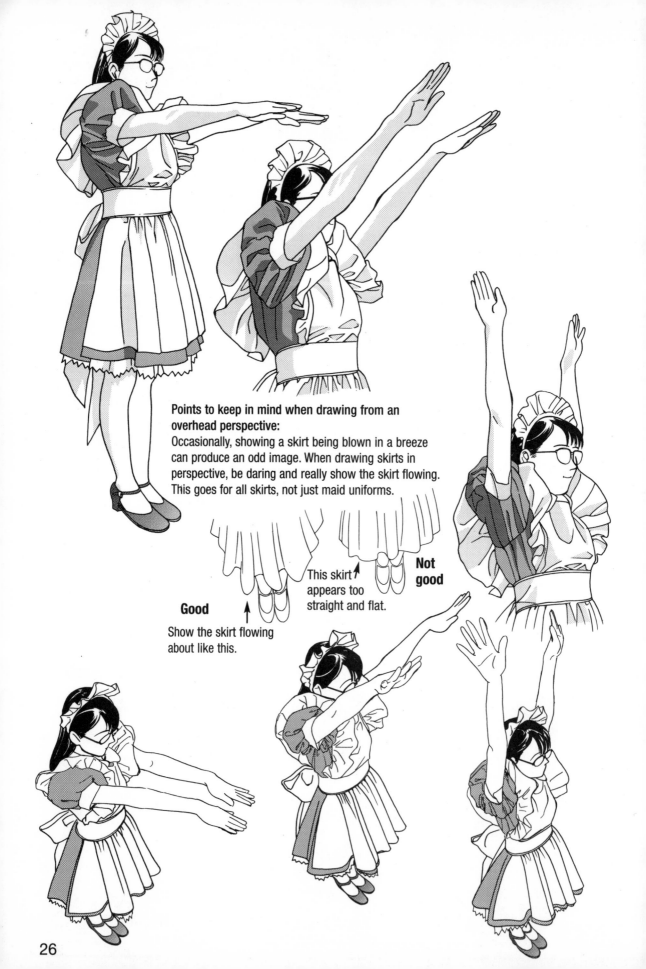

Points to keep in mind when drawing from an overhead perspective:
Occasionally, showing a skirt being blown in a breeze can produce an odd image. When drawing skirts in perspective, be daring and really show the skirt flowing. This goes for all skirts, not just maid uniforms.

This skirt ↗ appears too straight and flat.

Not good

Good ↑

Show the skirt flowing about like this.

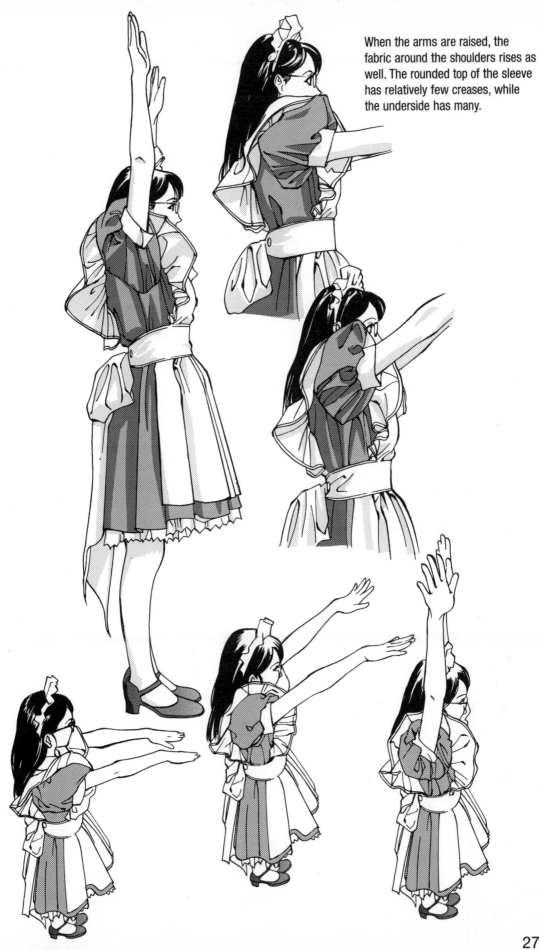

When the arms are raised, the fabric around the shoulders rises as well. The rounded top of the sleeve has relatively few creases, while the underside has many.

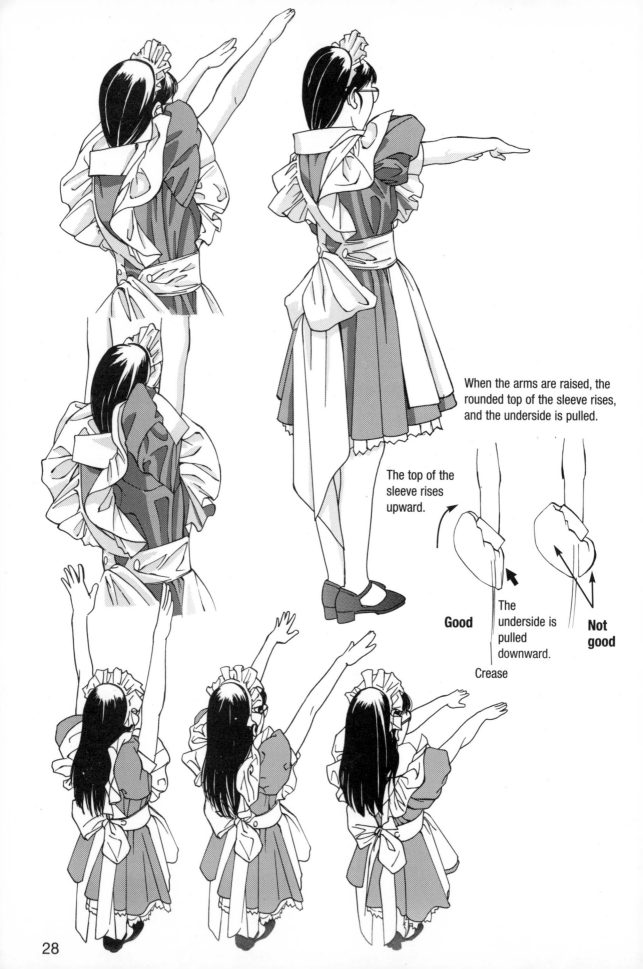

When the arms are raised, the rounded top of the sleeve rises, and the underside is pulled.

The top of the sleeve rises upward.

Good

The underside is pulled downward.

Crease

Not good

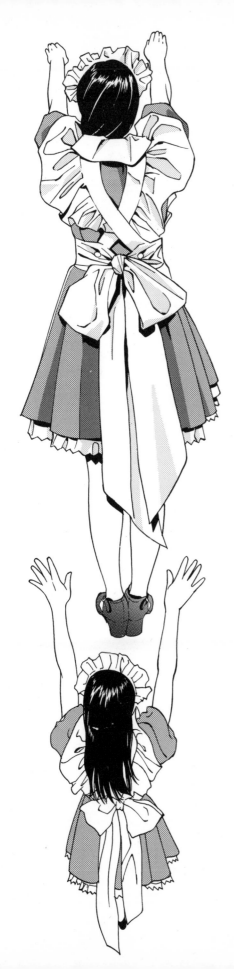

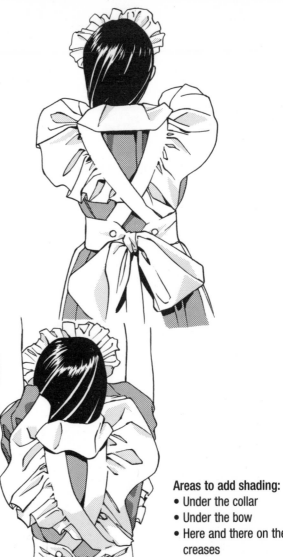

Areas to add shading:
- Under the collar
- Under the bow
- Here and there on the creases
- Underneath the skirt
- Here and there on the bottom of the creases

Both Arms Raised to the Side

The sleeve is pulled toward the body. Represent this by showing creases at an oblique angle.

Good

Avoid drawing horizontal creases.

Not good

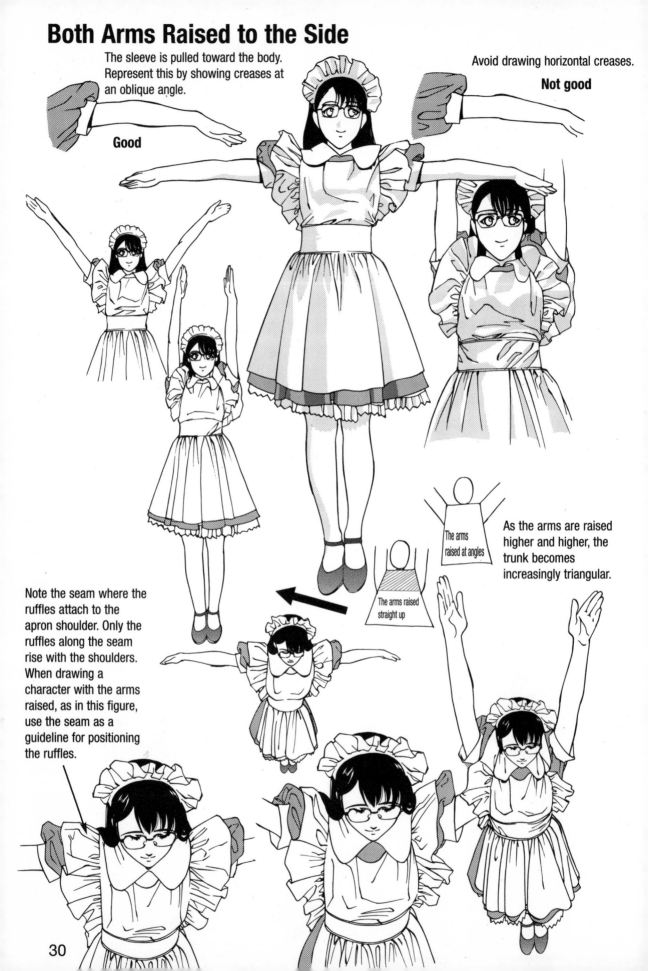

The arms raised at angles

The arms raised straight up

As the arms are raised higher and higher, the trunk becomes increasingly triangular.

Note the seam where the ruffles attach to the apron shoulder. Only the ruffles along the seam rise with the shoulders. When drawing a character with the arms raised, as in this figure, use the seam as a guideline for positioning the ruffles.

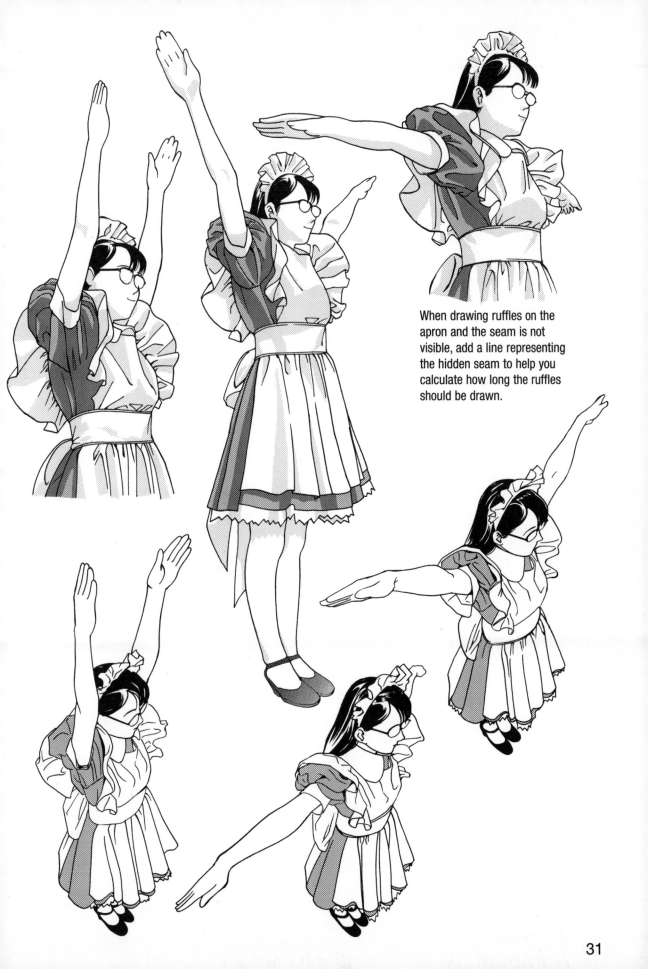

When drawing ruffles on the apron and the seam is not visible, add a line representing the hidden seam to help you calculate how long the ruffles should be drawn.

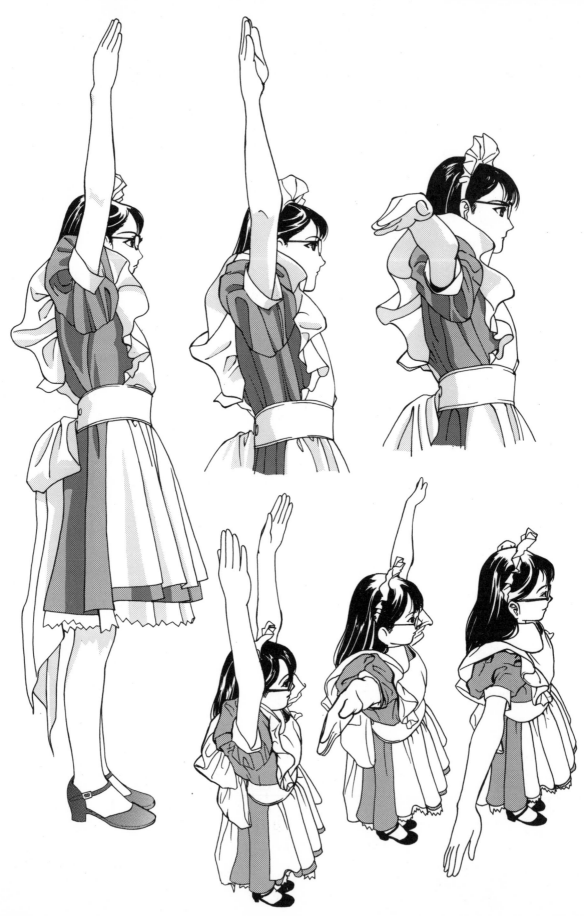

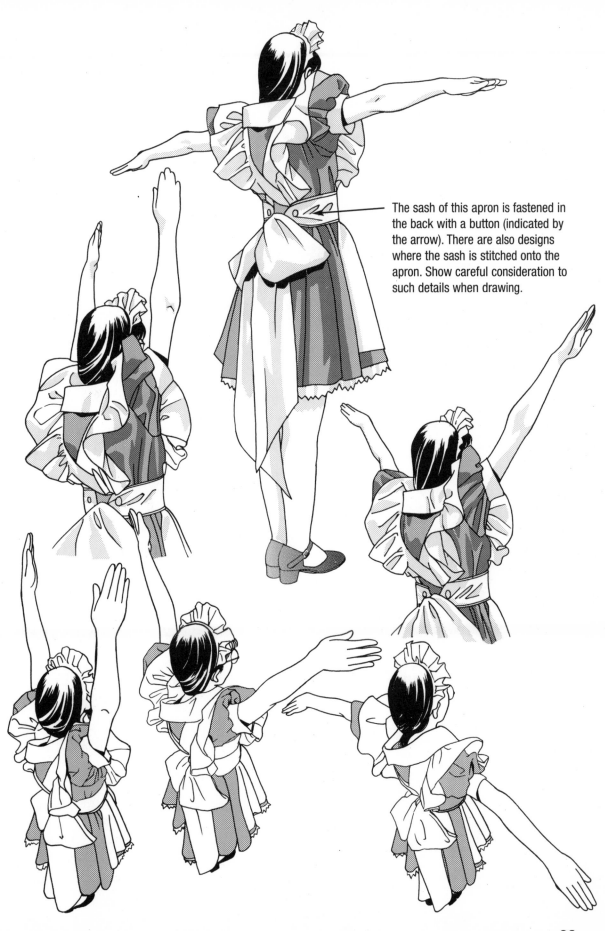

The sash of this apron is fastened in the back with a button (indicated by the arrow). There are also designs where the sash is stitched onto the apron. Show careful consideration to such details when drawing.

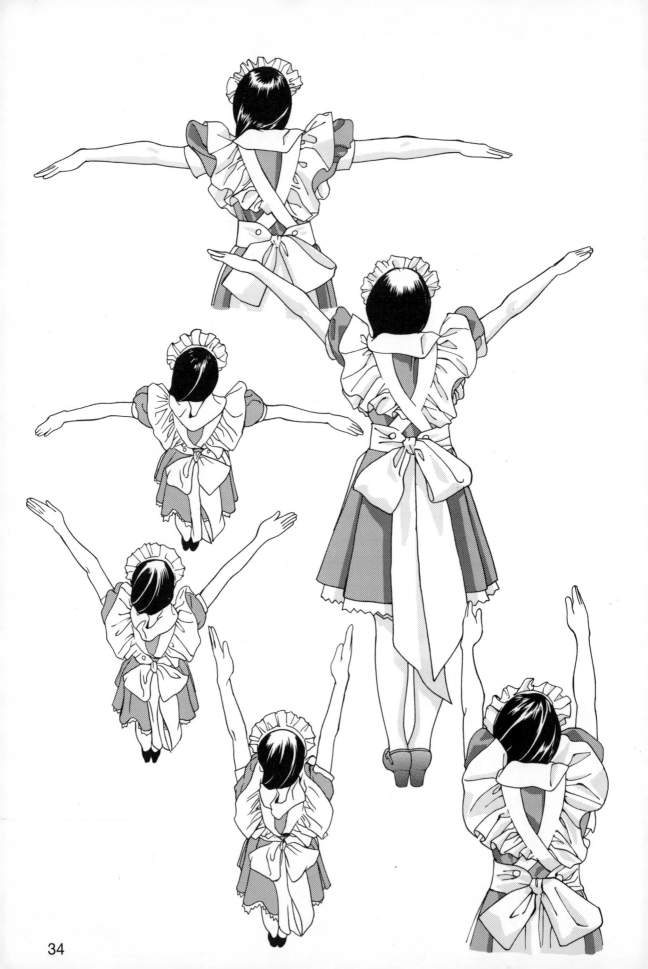

One Arm Raised Forward

The appearance of creases around the shoulder changes according to whether the arm is raised forward or to the side. Pay careful attention to this point when drawing.

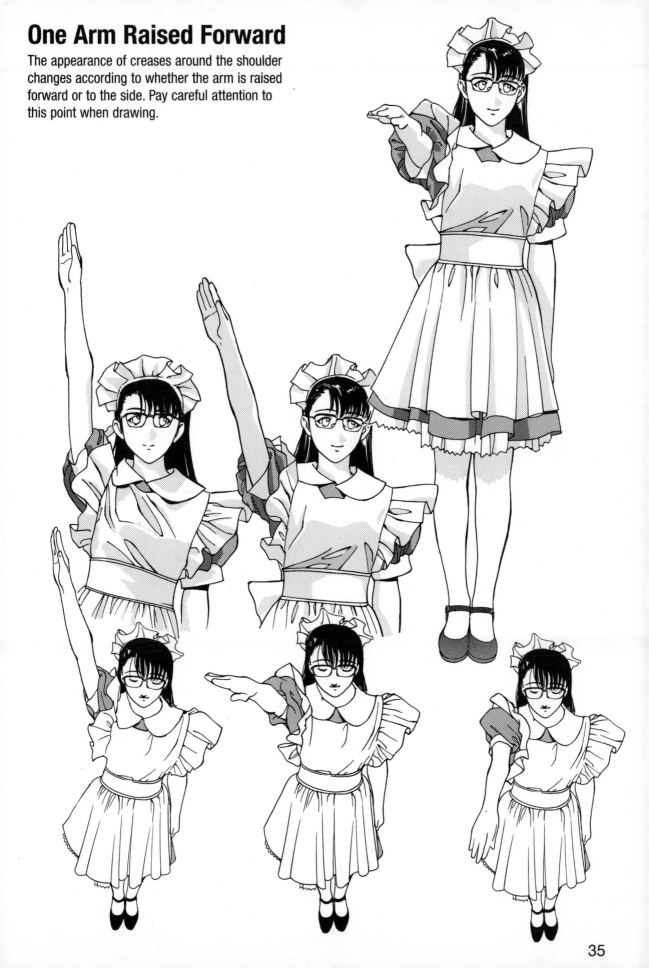

Key Points in Drawing One Arm Raised

When an arm is raised, changes occur around the shoulder.

For example, the shoulder rises. This becomes obvious if you take note of the collarbone. This is because the trapezius, a triangular muscle located between the neck and the shoulder, contracts, thereby shortening the distance between the shoulder and neck.

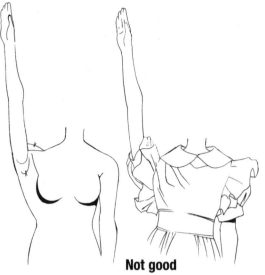

Not good

Not changing the appearance of the shoulder will result in an awkward drawing where the character's shoulders appear unnaturally broad, as in the figure above.

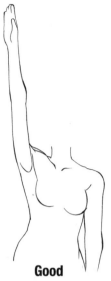

Good

A drawing of the shoulder rising should appear something like this. Showing the collarbone rising as well will result in a natural image.

Key Points in Drawing an Overhead Perspective of a Character with Raised Arms

The overhead perspective is one with a high angle. The higher the angle, the more dramatic the foreshortening required becomes, such as in Figure A. Avoid drawing the trunk as a trapezoid, as in Figure B, or as if viewed directly from the front, as in Figure C.

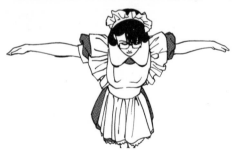

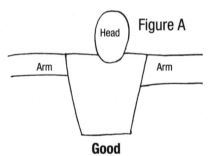

Figure A

Head

Arm Arm

Good

Figure B

Trapezoid

Not good

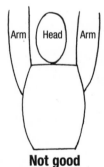

Figure D

Arm Head Arm

Simply drawing the contour lines without giving them careful consideration will result in something like Figure D, where the viewer seems to be looking directly at the head. This mistake arises when no attention is paid to the body's thickness or to lines hidden by shadows from this angle. A correctly drawn overhead perspective will appear more like Figure E.

Not good

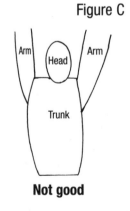

Figure C

Arm Arm
 Head

Trunk

Not good

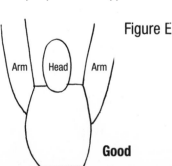

Figure E

Arm Head Arm

Good

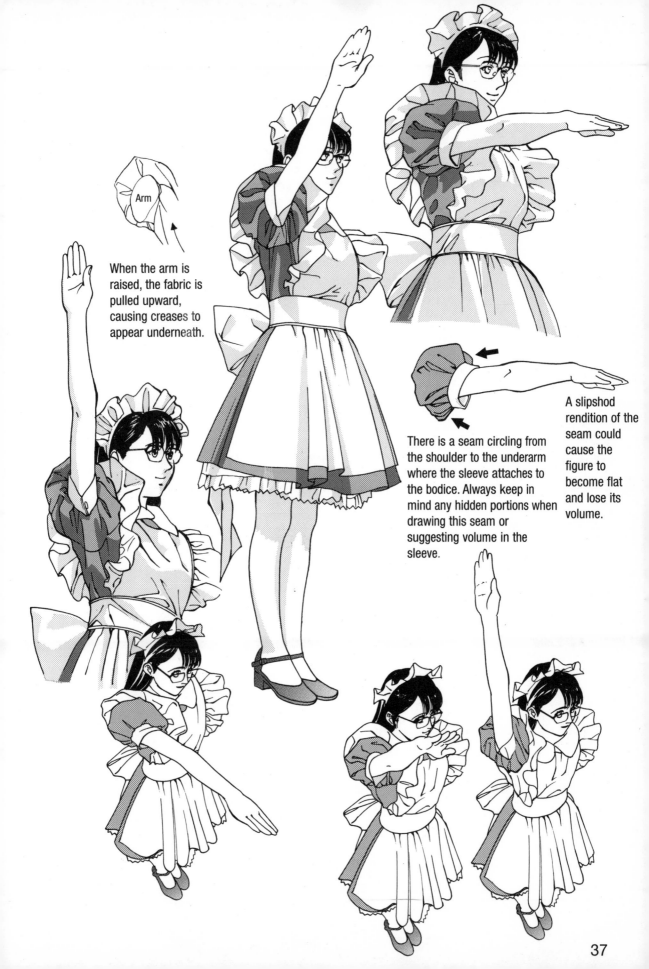

Arm

When the arm is
raised, the fabric is
pulled upward,
causing creases to
appear underneath.

There is a seam circling from
the shoulder to the underarm
where the sleeve attaches to
the bodice. Always keep in
mind any hidden portions when
drawing this seam or
suggesting volume in the
sleeve.

A slipshod
rendition of the
seam could
cause the
figure to
become flat
and lose its
volume.

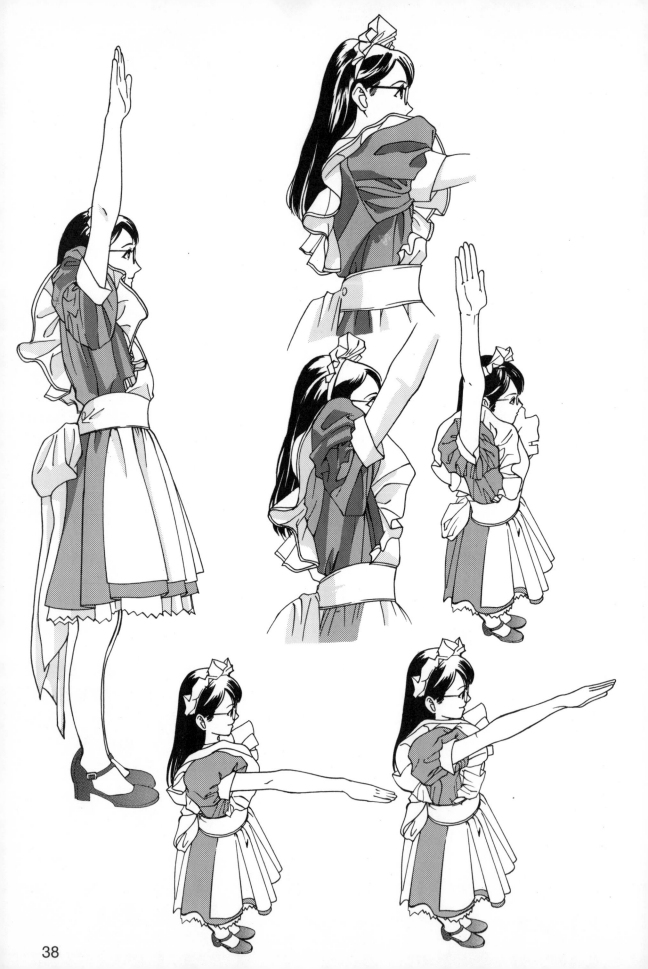

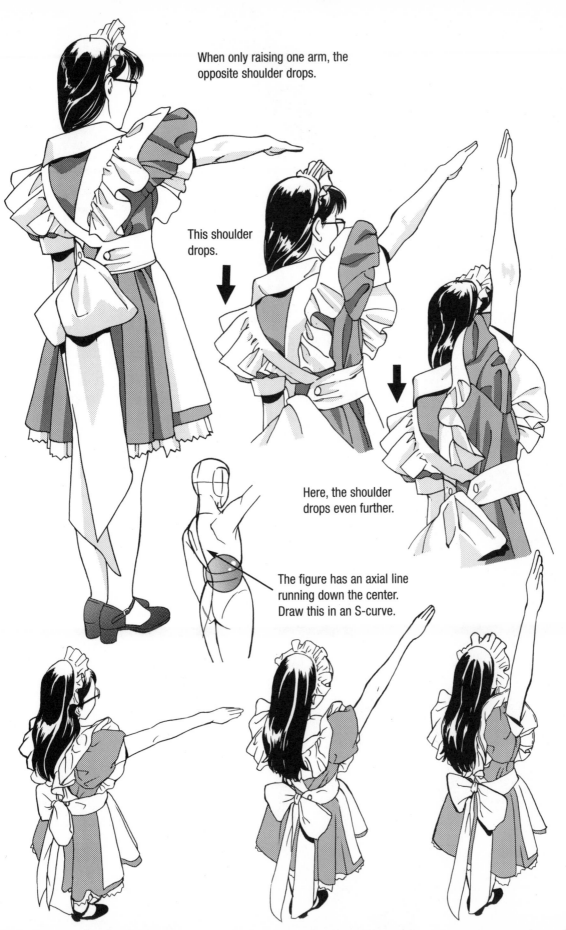

When only raising one arm, the opposite shoulder drops.

This shoulder drops.

Here, the shoulder drops even further.

The figure has an axial line running down the center. Draw this in an S-curve.

The Sleeves

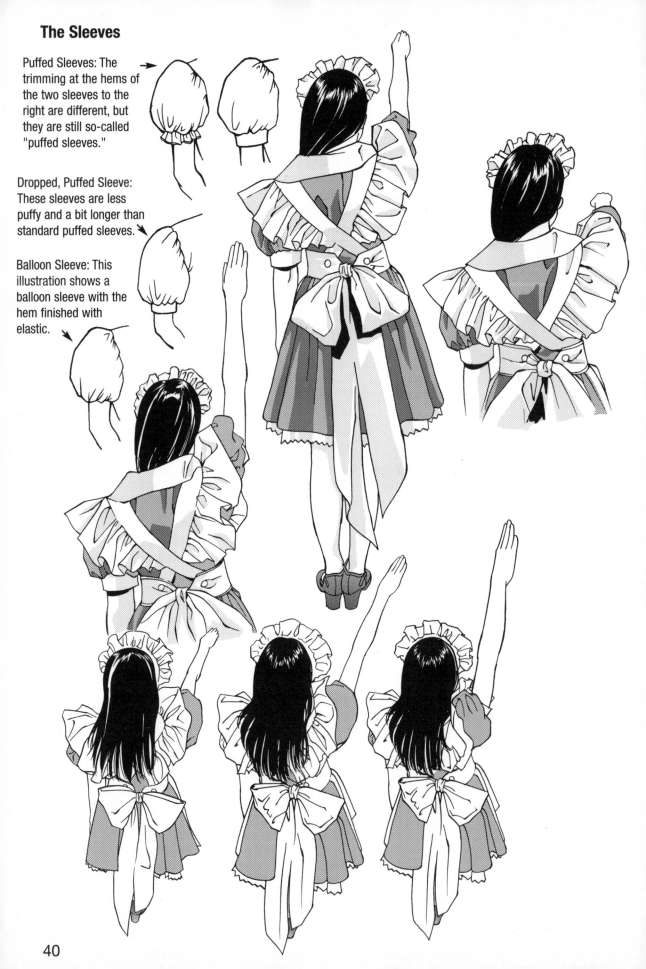

Puffed Sleeves: The trimming at the hems of the two sleeves to the right are different, but they are still so-called "puffed sleeves."

Dropped, Puffed Sleeve: These sleeves are less puffy and a bit longer than standard puffed sleeves.

Balloon Sleeve: This illustration shows a balloon sleeve with the hem finished with elastic.

40

One Arm Raised to the Side

Note how the shoulder and bib of the apron change position as the arm is raised.

Adding a shadow cast by the collar against the neck makes the overall composition appear busy. This holds true for all types of art, including manga. However, it is effective in key drawings and other intricate artwork.

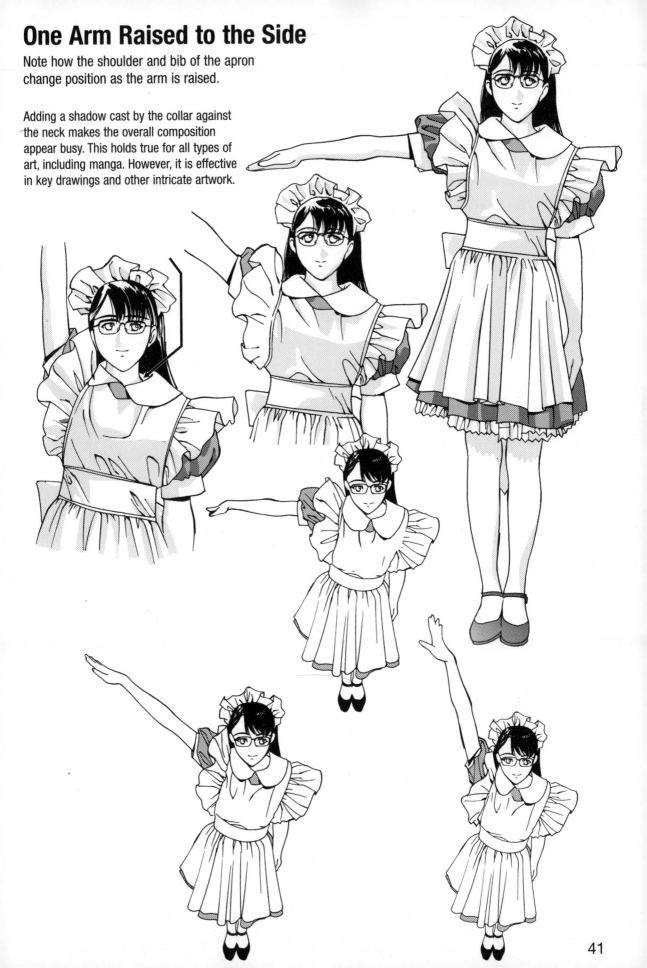

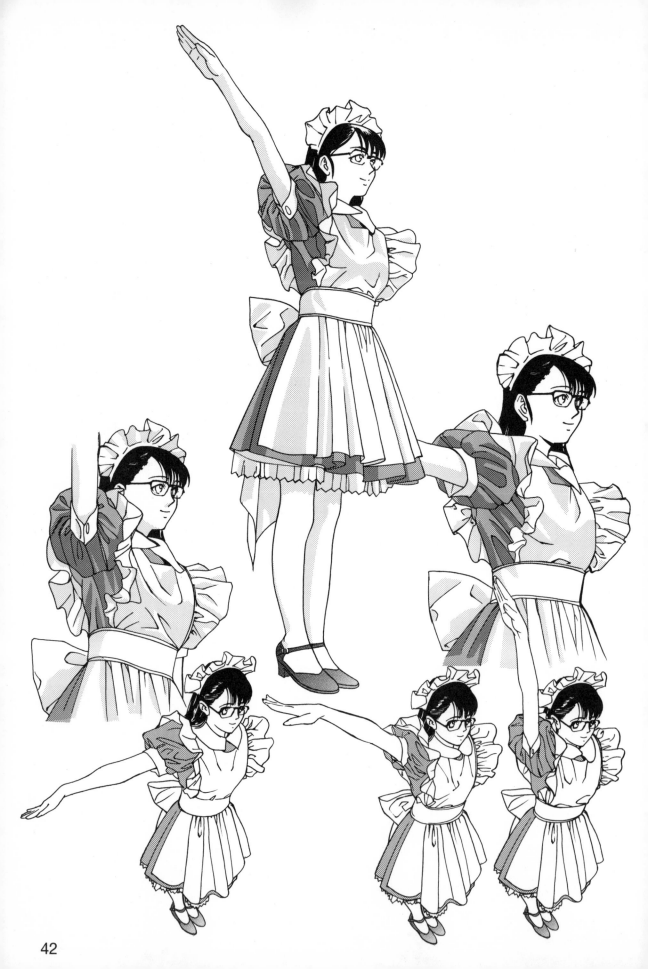

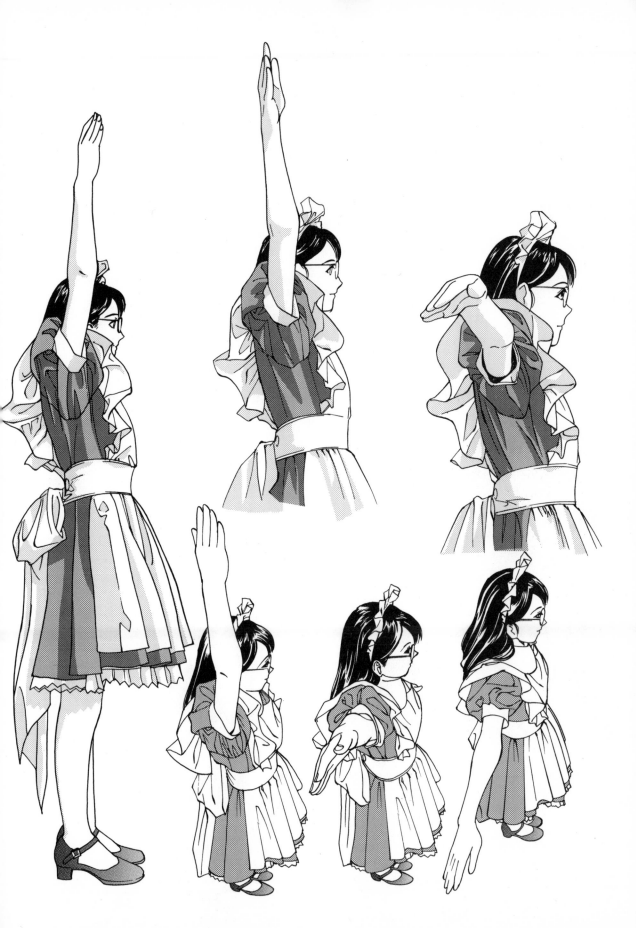

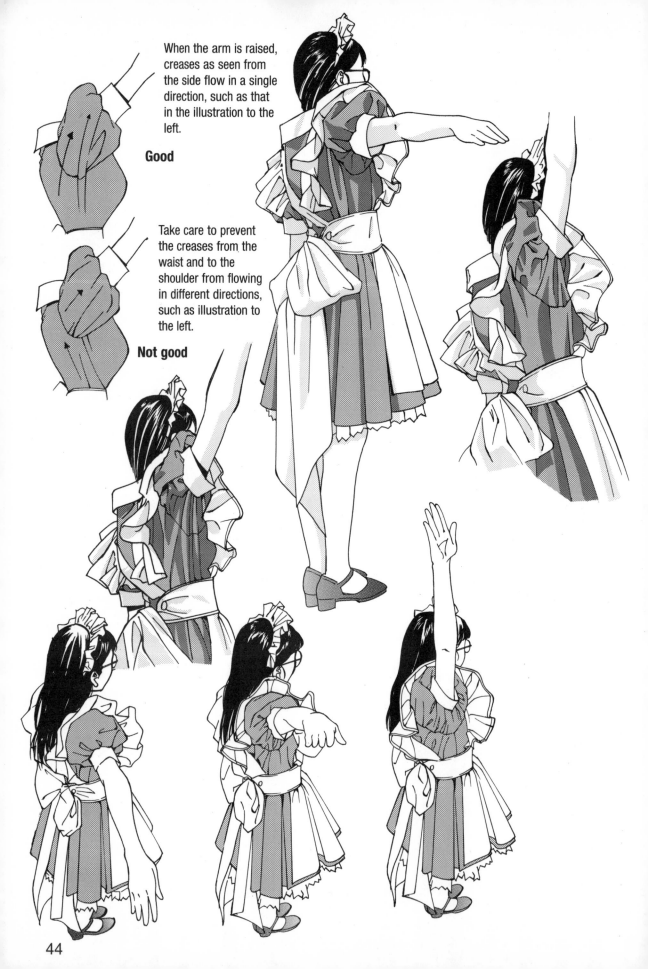

When the arm is raised, creases as seen from the side flow in a single direction, such as that in the illustration to the left.

Good

Take care to prevent the creases from the waist and to the shoulder from flowing in different directions, such as illustration to the left.

Not good

The Sleeves

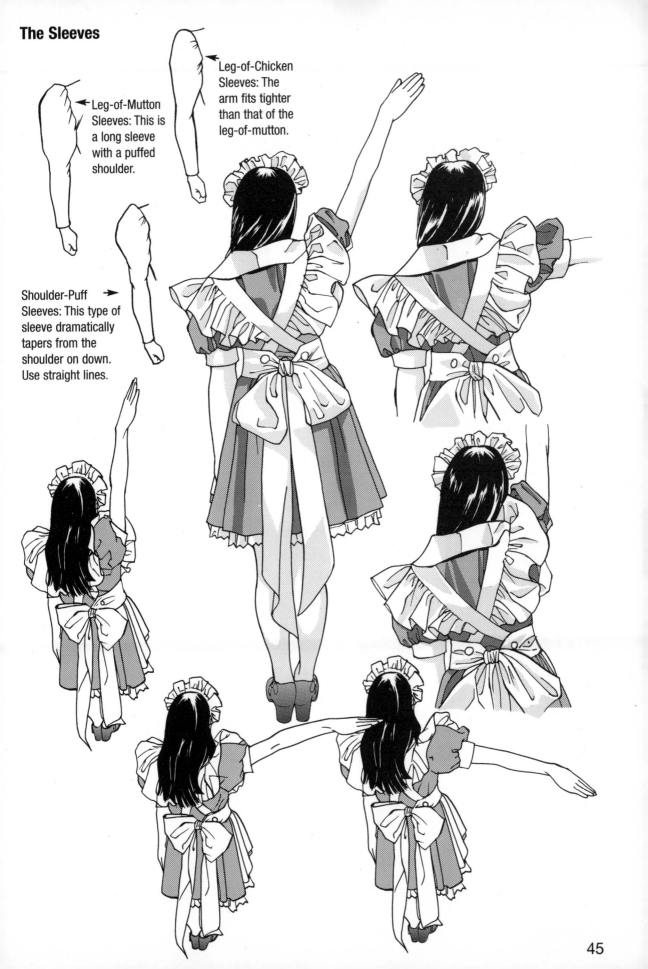

Leg-of-Mutton Sleeves: This is a long sleeve with a puffed shoulder.

Leg-of-Chicken Sleeves: The arm fits tighter than that of the leg-of-mutton.

Shoulder-Puff Sleeves: This type of sleeve dramatically tapers from the shoulder on down. Use straight lines.

Sitting

When adding skirt creases to a seated character, it is extremely important to gain an idea of the overall form to avoid drawing the creases incorrectly.

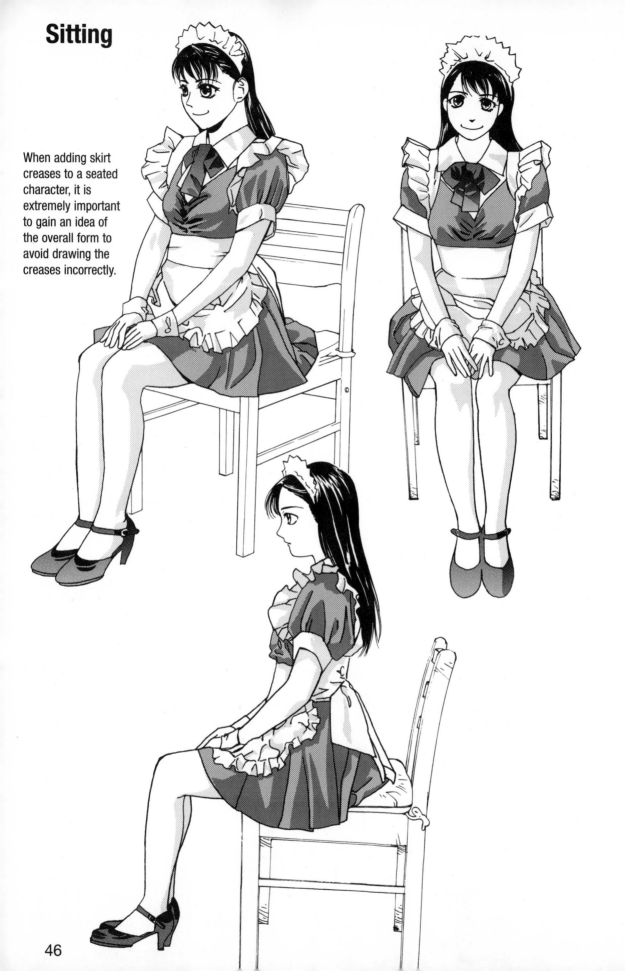

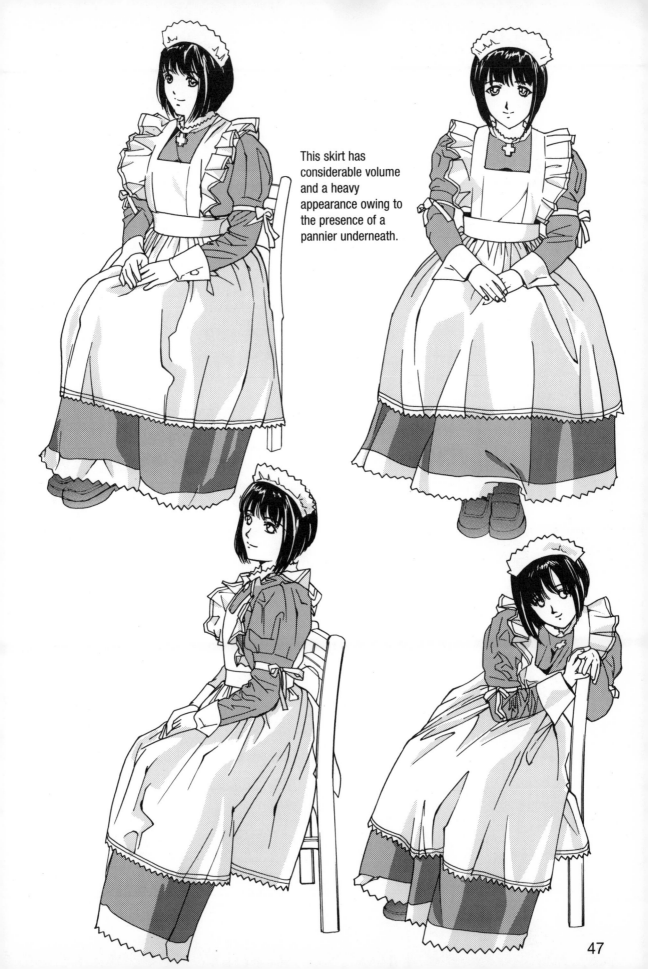

This skirt has considerable volume and a heavy appearance owing to the presence of a pannier underneath.

Sitting with the Legs Crossed

The following pages show uniforms with two skirt lengths: a mini and a below-the-knee.

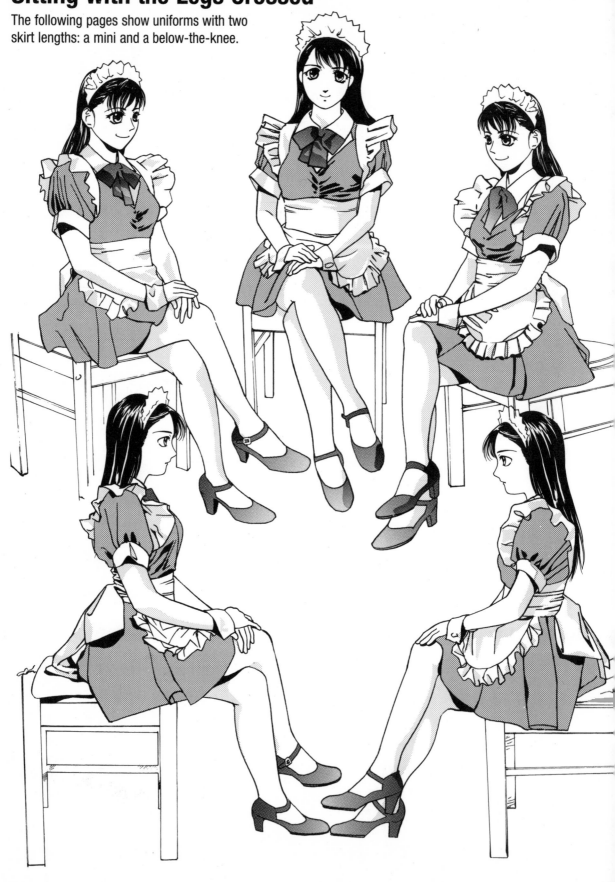

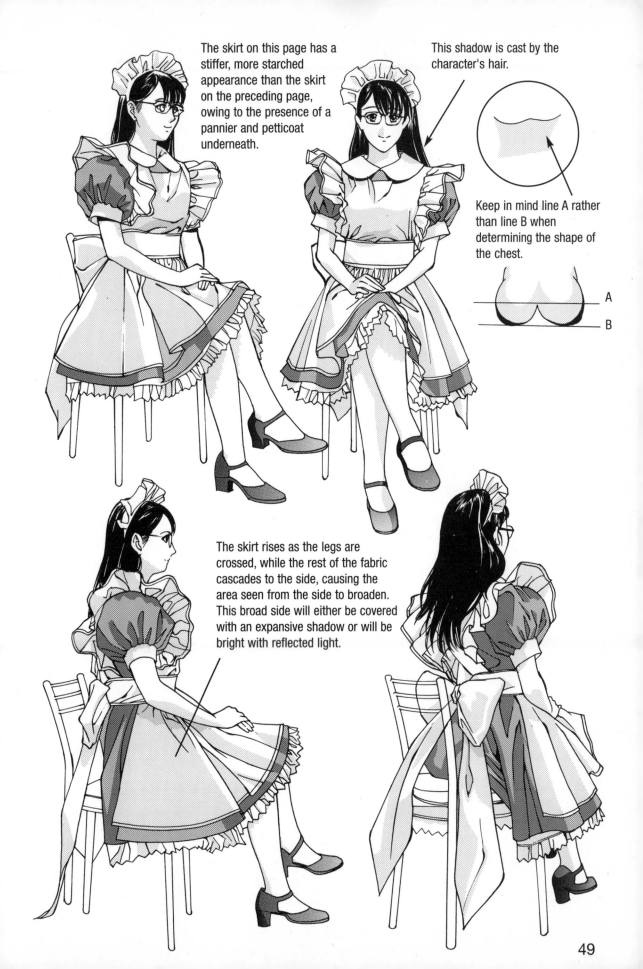

The skirt on this page has a stiffer, more starched appearance than the skirt on the preceding page, owing to the presence of a pannier and petticoat underneath.

This shadow is cast by the character's hair.

Keep in mind line A rather than line B when determining the shape of the chest.

A
B

The skirt rises as the legs are crossed, while the rest of the fabric cascades to the side, causing the area seen from the side to broaden. This broad side will either be covered with an expansive shadow or will be bright with reflected light.

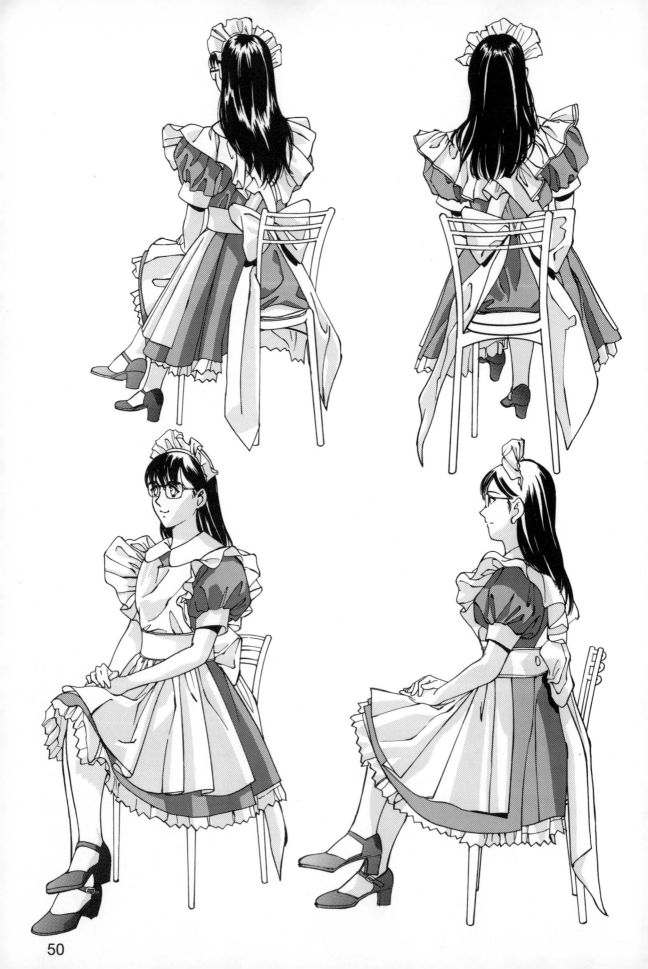

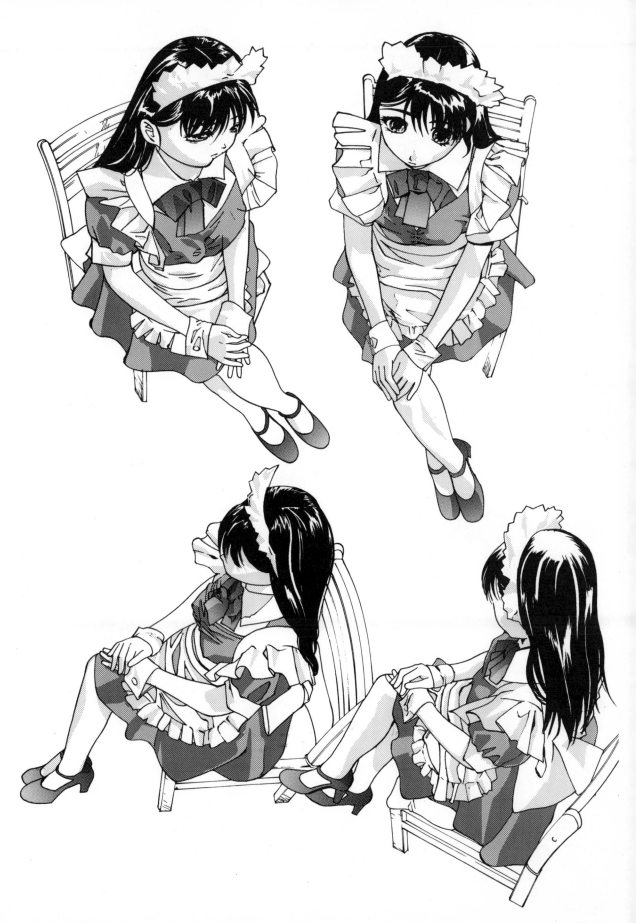

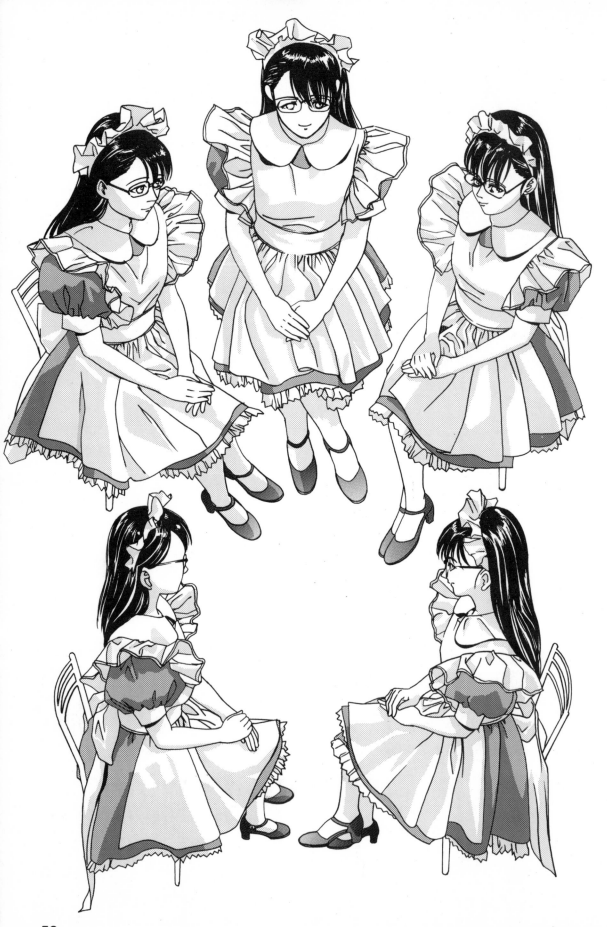

Sitting Primly on the Floor (Legs Tucked Underneath)

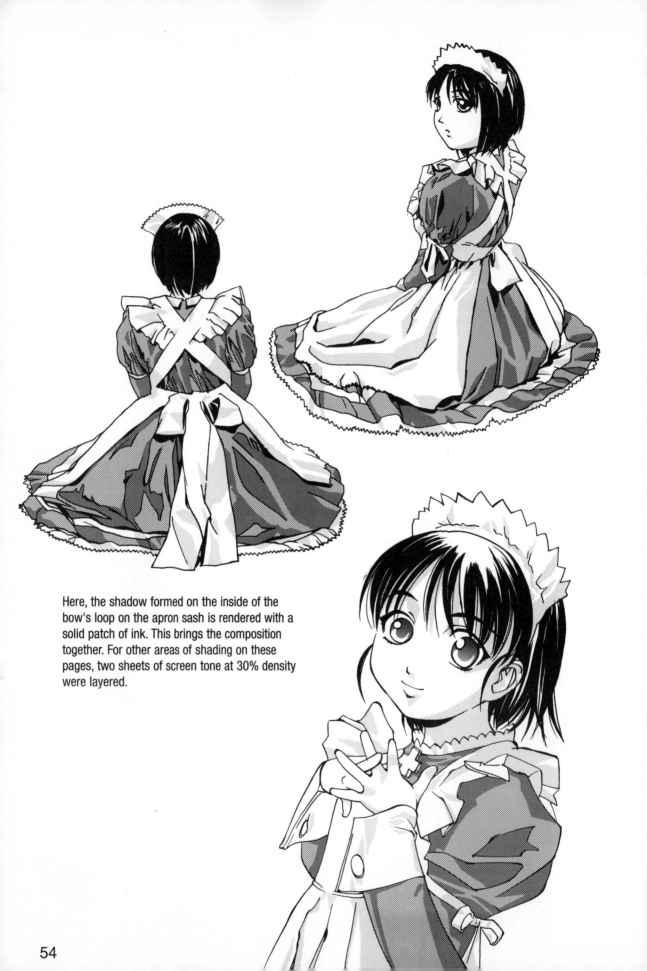

Here, the shadow formed on the inside of the bow's loop on the apron sash is rendered with a solid patch of ink. This brings the composition together. For other areas of shading on these pages, two sheets of screen tone at 30% density were layered.

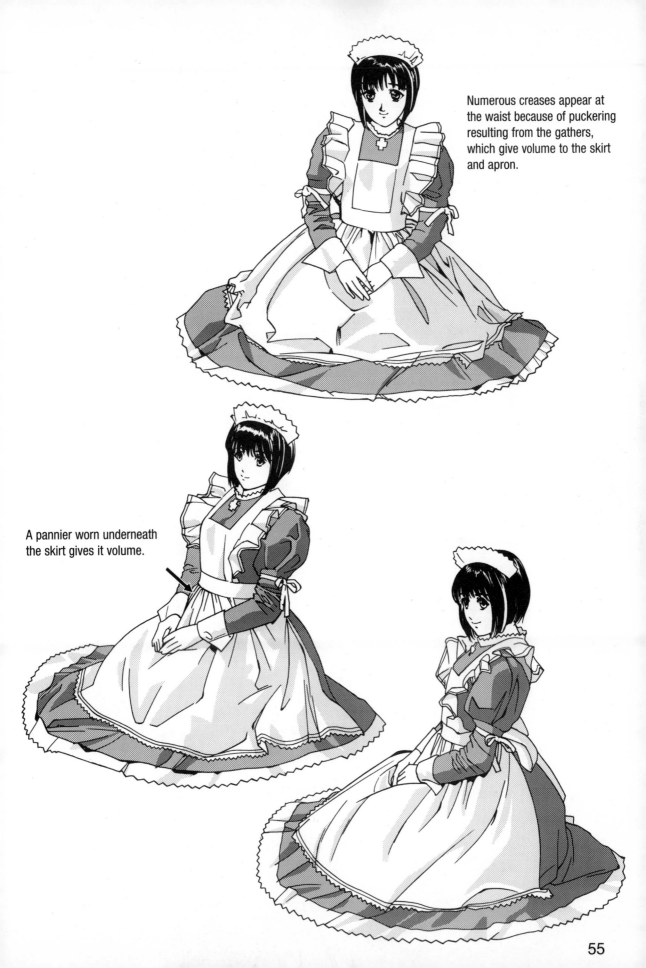

Numerous creases appear at
the waist because of puckering
resulting from the gathers,
which give volume to the skirt
and apron.

A pannier worn underneath
the skirt gives it volume.

Sitting on the Floor, Holding the Legs

Adding large, bold patches of shading rather than detailed shadows to suggest numerous tiny rises is a more effecting means of shading relatively flat areas of fabric with only subtle undulations.

Light Source

Side view of hem

Use large shadows to suggest the flow of fabric.

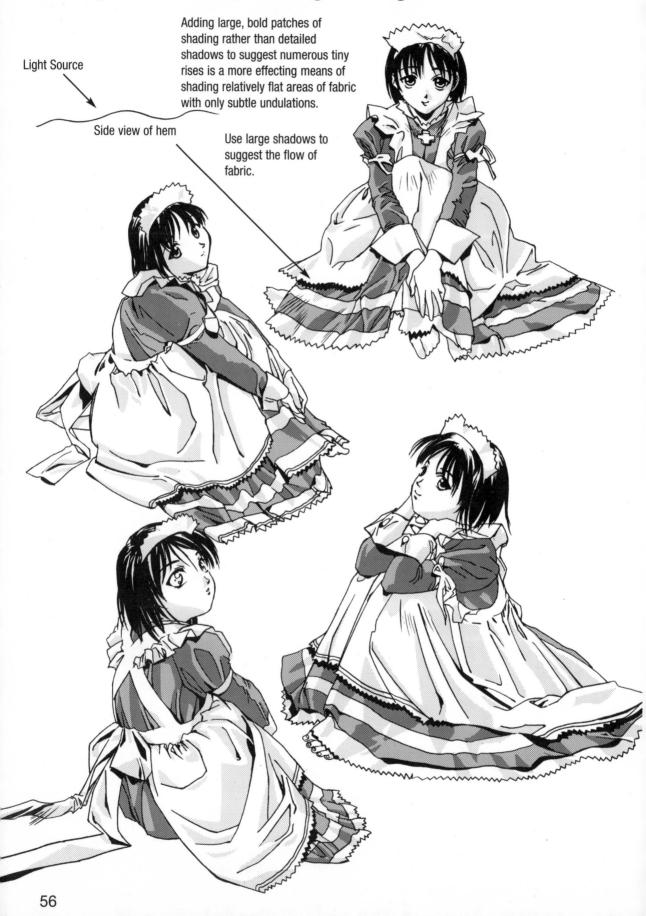

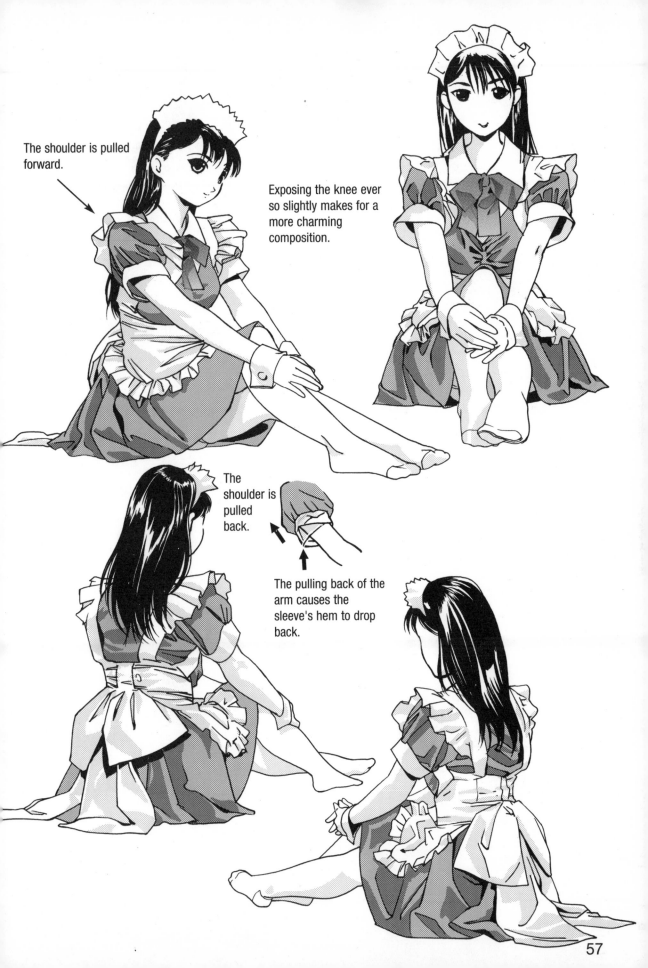

The shoulder is pulled forward.

Exposing the knee ever so slightly makes for a more charming composition.

The shoulder is pulled back.

The pulling back of the arm causes the sleeve's hem to drop back.

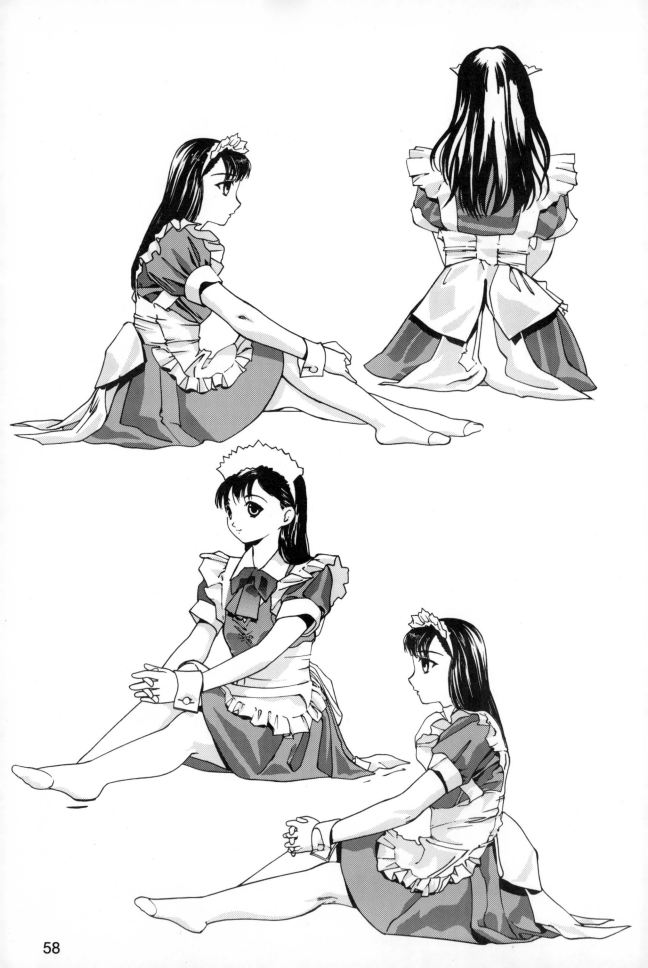

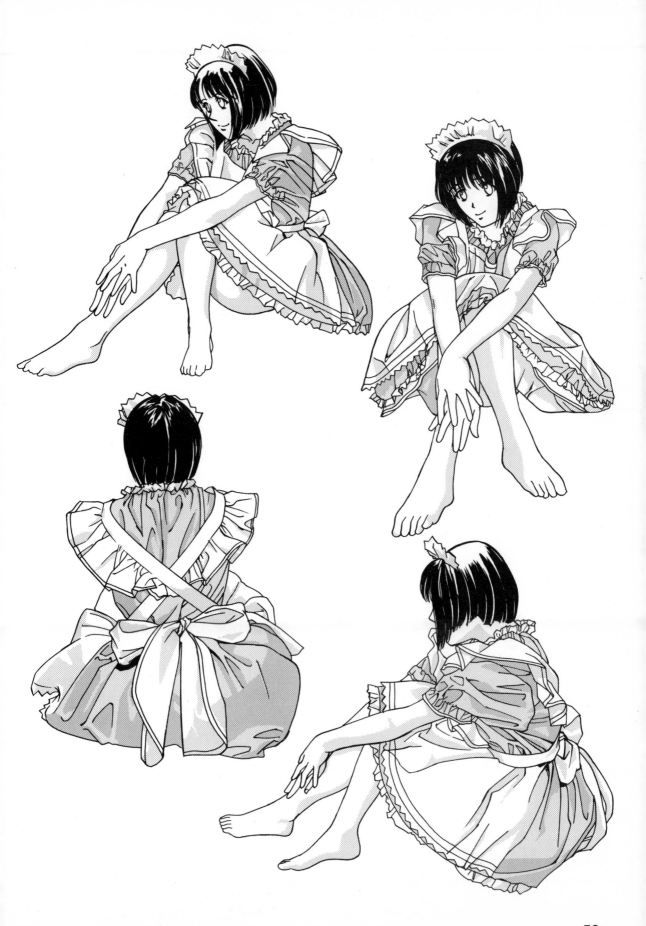

Sitting on the Floor, Legs Extended

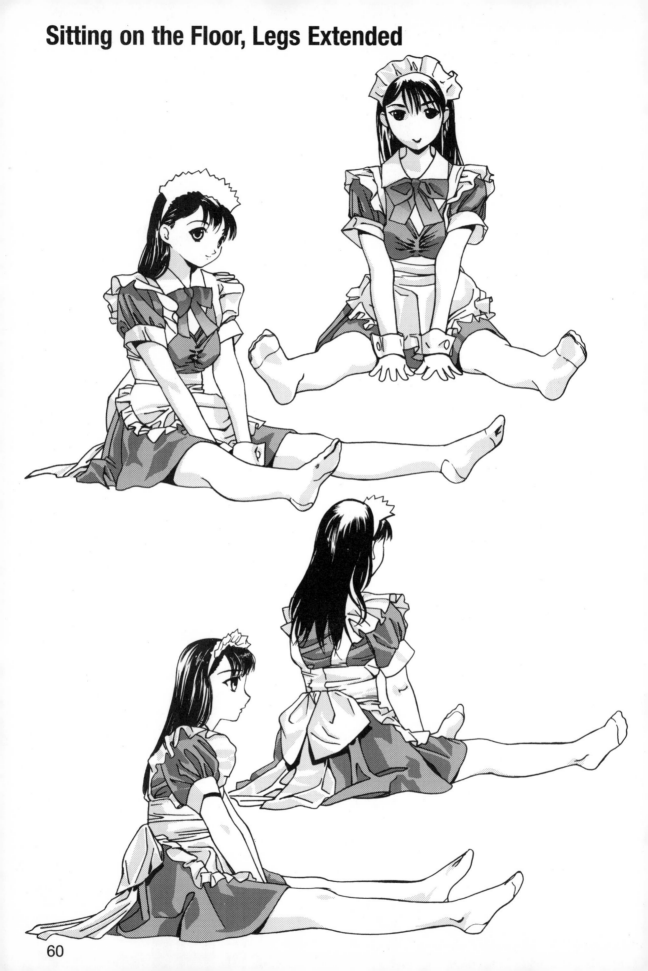

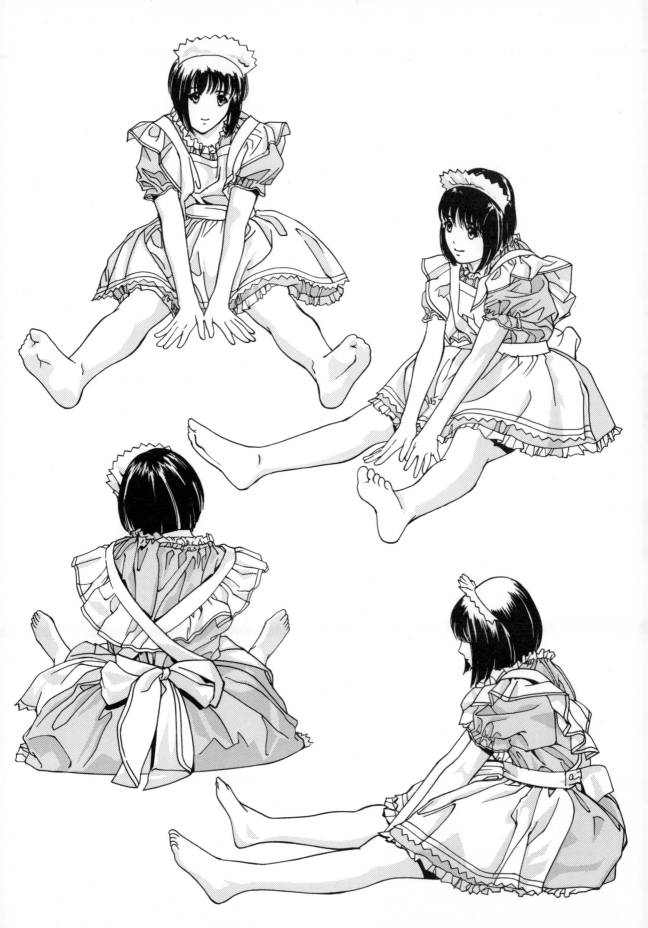

Kneeling on One Leg

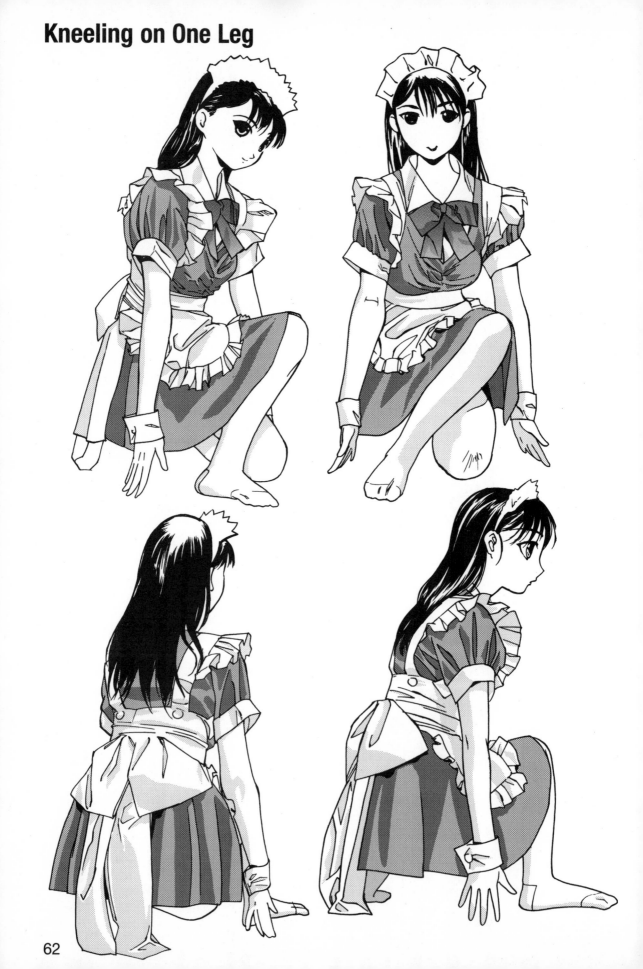

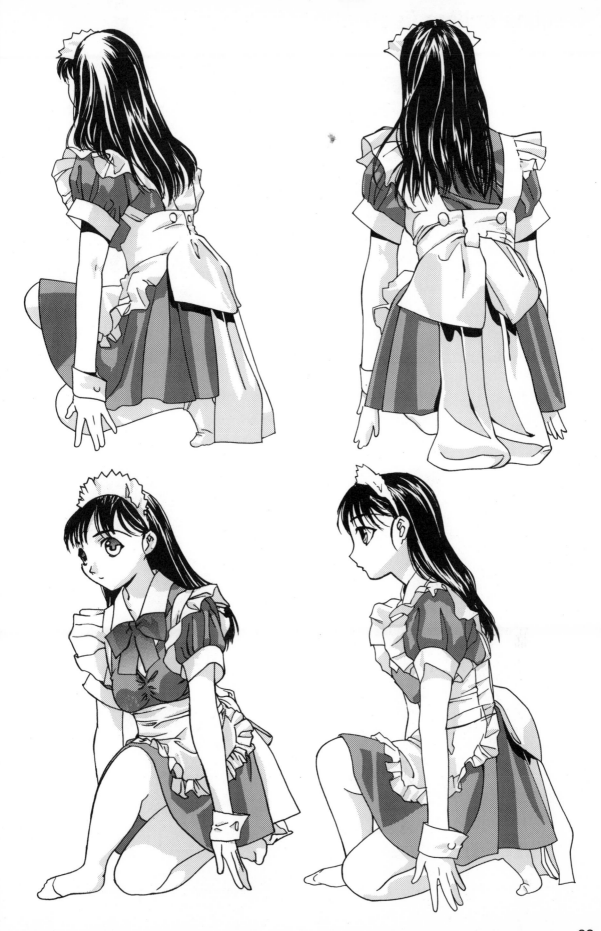

Sitting with Legs Tucked to the Side

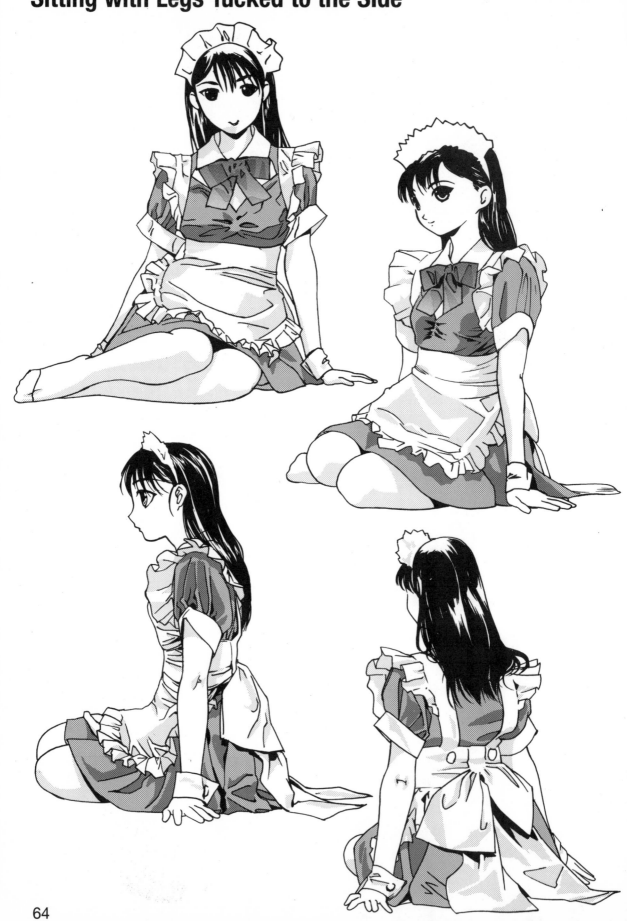

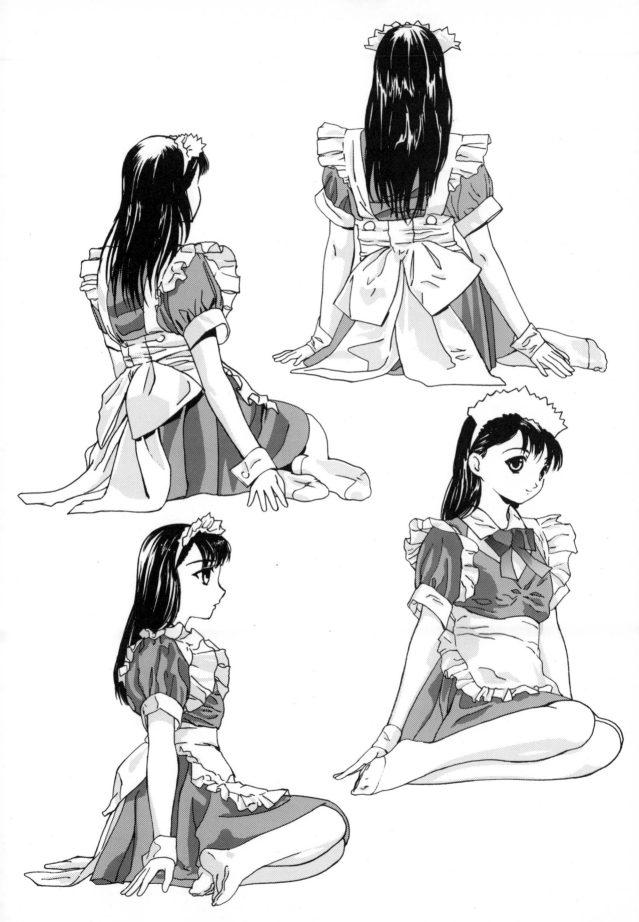

Sitting with Knees Together and Feet Out

Kneeling on All Fours

Problem: (Left illustration) How should you draw the apron's shoulders when the waist is hidden? Where should the apron's bow be positioned?

Solution: Sketch the contours of the waist, which will be hidden from view in the final drawing. Drawing it in this way and paying attention to where it would be positioned will allow you to grasp automatically where the apron's shoulders and bow should be.

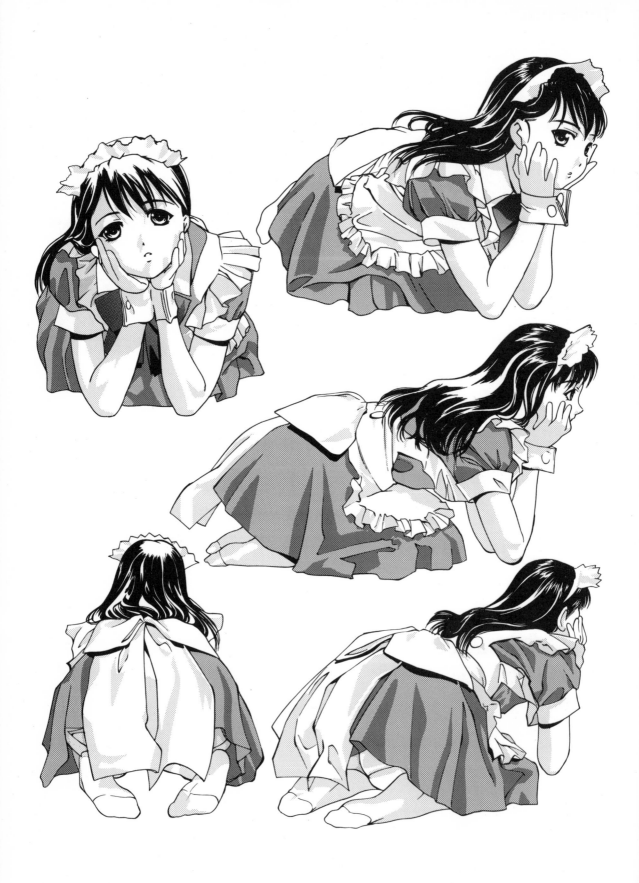

Reclining

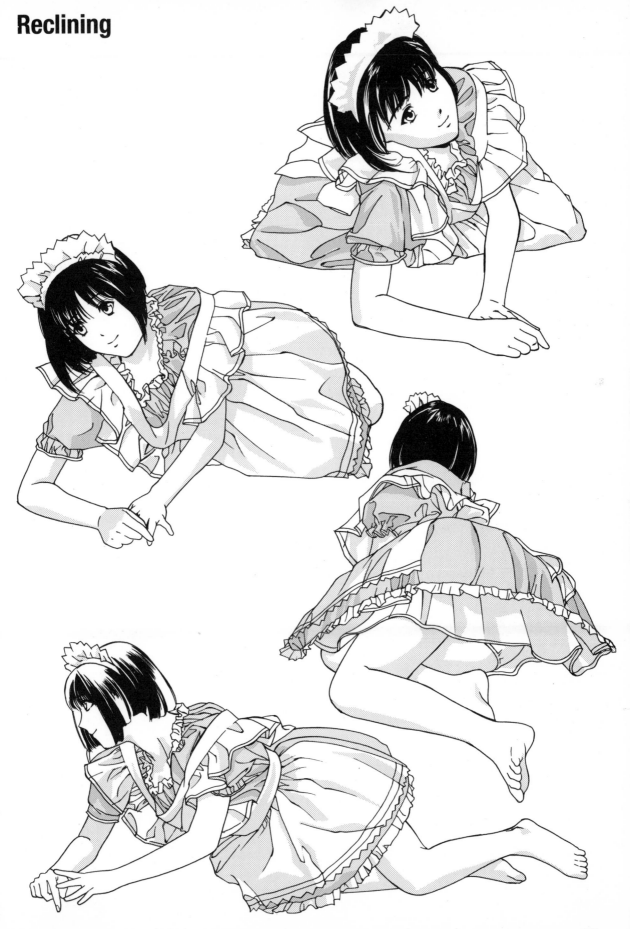

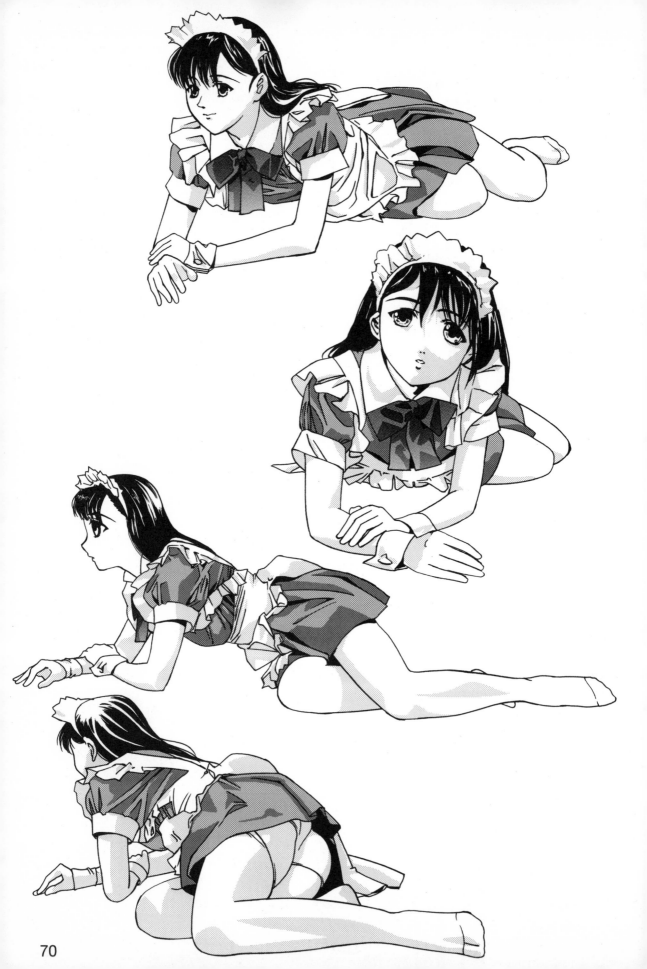

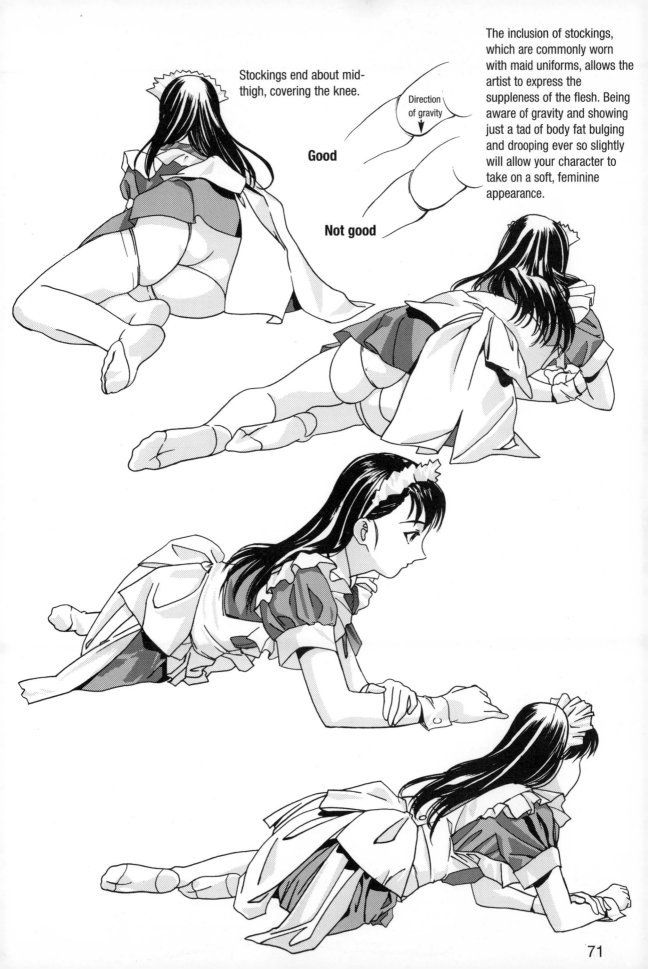

Stockings end about mid-thigh, covering the knee.

Direction of gravity

Good

Not good

The inclusion of stockings, which are commonly worn with maid uniforms, allows the artist to express the suppleness of the flesh. Being aware of gravity and showing just a tad of body fat bulging and drooping ever so slightly will allow your character to take on a soft, feminine appearance.

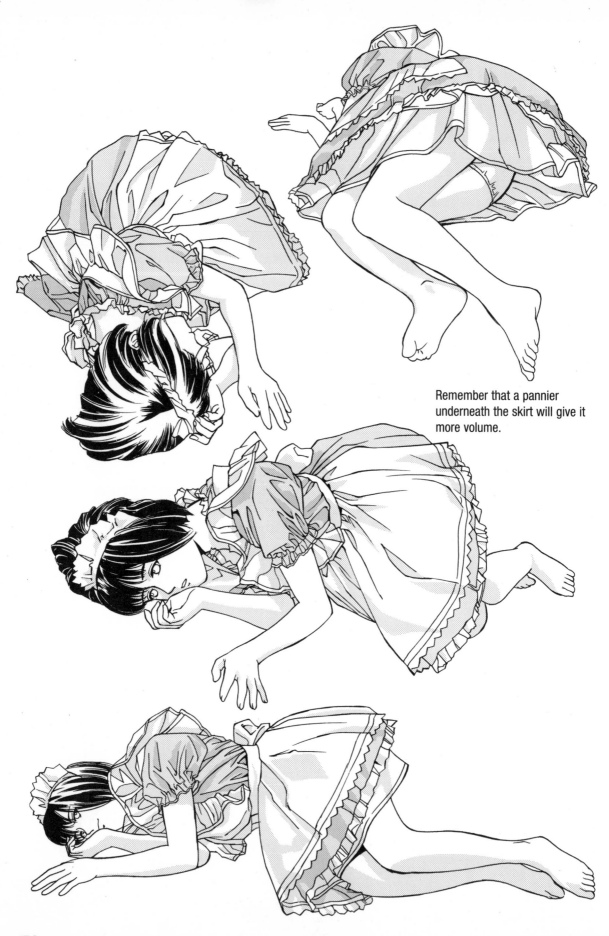

Remember that a pannier underneath the skirt will give it more volume.

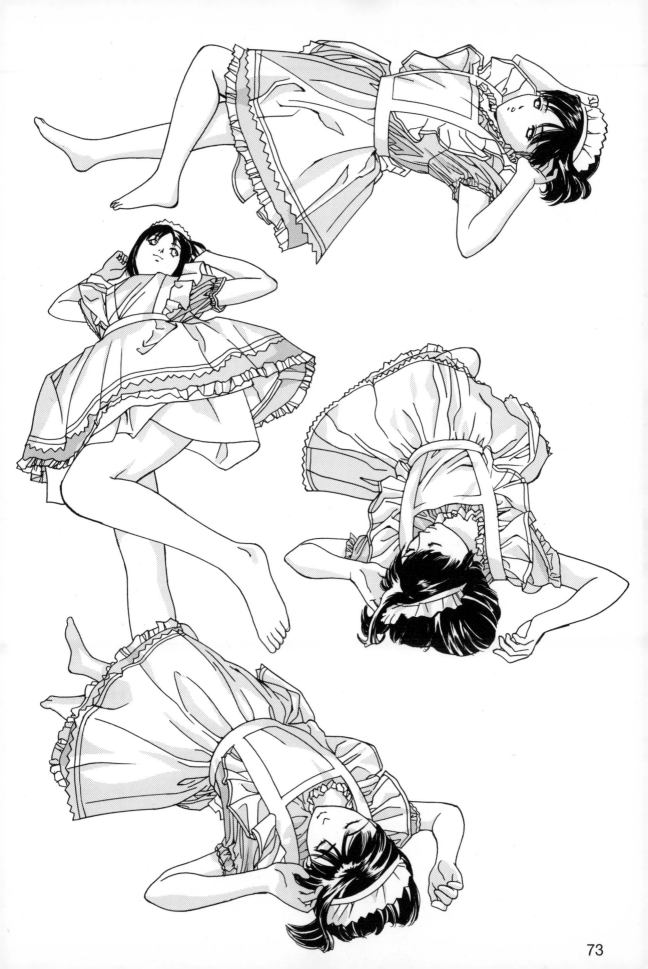

Shading and Shadows

Figure A shows both shading on the side opposite the light source and the shadow cast by the object on the ground. Just to experiment, a solid black shadow (referred to as "BL" in the world of anime) was added to Figure B. This resulted in an image with very high contrast.

There are times when such an idiosyncratic touch might be desirable. However, for the time being, here are a few suggestions for using solid black shading effectively.

There are some set rules to adding solid black shading. If you commit them to memory, you should improve your artwork by having a very effective technique at your disposal.

Figure A

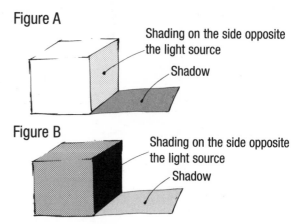

Shading on the side opposite the light source

Shadow

Figure B

Shading on the side opposite the light source

Shadow

Modulate the values of the shading you use to give the composition balance and create a sense of depth. Screen tone of 10% density was used for the shading on the box's side in Figure A above, while one of 30% was used for the shadow on the ground. Conversely, since the value of the shadow on the side of the box in Figure B is inherently dark, a lighter-valued tone of 10% was used for the shadow on the ground. Give thought to the combination of tone values and the overall composition when shading.

Light Source

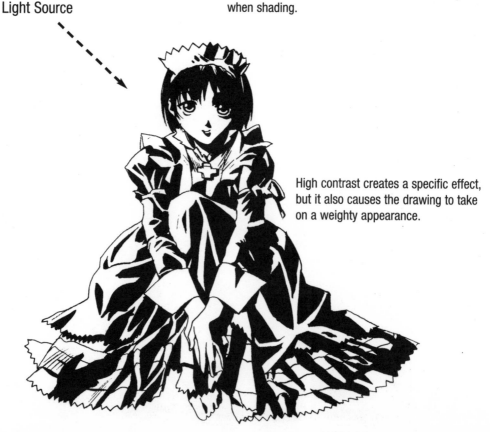

High contrast creates a specific effect, but it also causes the drawing to take on a weighty appearance.

Using Solid Black Effectively

For the chest and peaks in creases and folds, use hatching or other hand-drawn shadows instead of solid patches of shading.

The shadows under the chin and under tiny ruffles and frills are small and delicate. Avoid using solid patches of black.

Avoid using solid patches of black shading on tiny bows, even if they are dark in color or value. If you absolutely have to use solid black shading, then use it on the entire bows.

Use solid black shading on dark items or for specific shadows on dark items. If you are simply adding general shading to the item, then avoid using solid black.

Use solid black in areas such as where a drawn line bends or where two lines intersect.

Shadow under the cuff

Use solid black in the crook of a fold. (Refer to Figures A, B, and C below.)

Use solid black for overlapping cloth. In this particular case, avoid adding lines for creases.

Use solid black for obvious shadows such as those underneath the character.

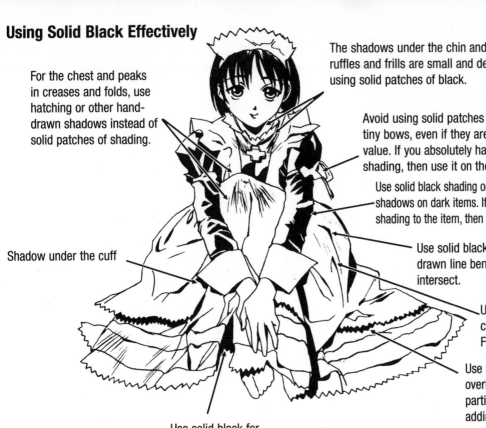

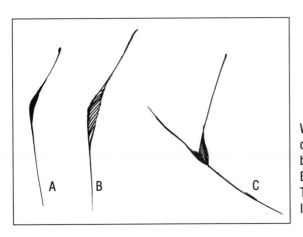

When a gray value is desirable over solid black, such as in Figure B, use hatching instead. This will result in a lighter touch.

Aaaahhhh!

Heh, heh!

Here's a little black shadow for your drawing, oh Master.

Crash Course in Editing

This is a drawing by a student participating in the Japan-based Society for the Study of Manga Techniques. Parts of the drawing appear awkward. But why? Let's take a close look.

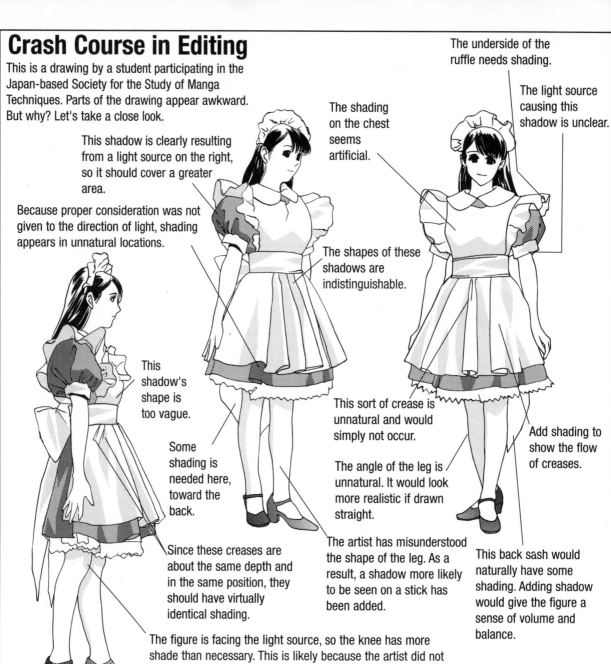

The underside of the ruffle needs shading.

The light source causing this shadow is unclear.

The shading on the chest seems artificial.

This shadow is clearly resulting from a light source on the right, so it should cover a greater area.

Because proper consideration was not given to the direction of light, shading appears in unnatural locations.

The shapes of these shadows are indistinguishable.

This shadow's shape is too vague.

Some shading is needed here, toward the back.

This sort of crease is unnatural and would simply not occur.

The angle of the leg is unnatural. It would look more realistic if drawn straight.

Add shading to show the flow of creases.

Since these creases are about the same depth and in the same position, they should have virtually identical shading.

The artist has misunderstood the shape of the leg. As a result, a shadow more likely to be seen on a stick has been added.

This back sash would naturally have some shading. Adding shadow would give the figure a sense of volume and balance.

The figure is facing the light source, so the knee has more shade than necessary. This is likely because the artist did not give sufficient consideration to the leg's volume or to the direction of light, but rather simply added decorative shadows following the contours of surrounding forms.

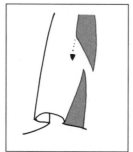

Figure A

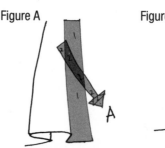

Figure B

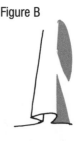

Even if upper and lower shadows are separated, they should follow a connected flow, as suggested by the dotted arrow. In fact, the shadows on Figure B have been added along the flow illustrated in Figure A. The dotted arrow in the boxed illustration shows this flow from top to bottom.

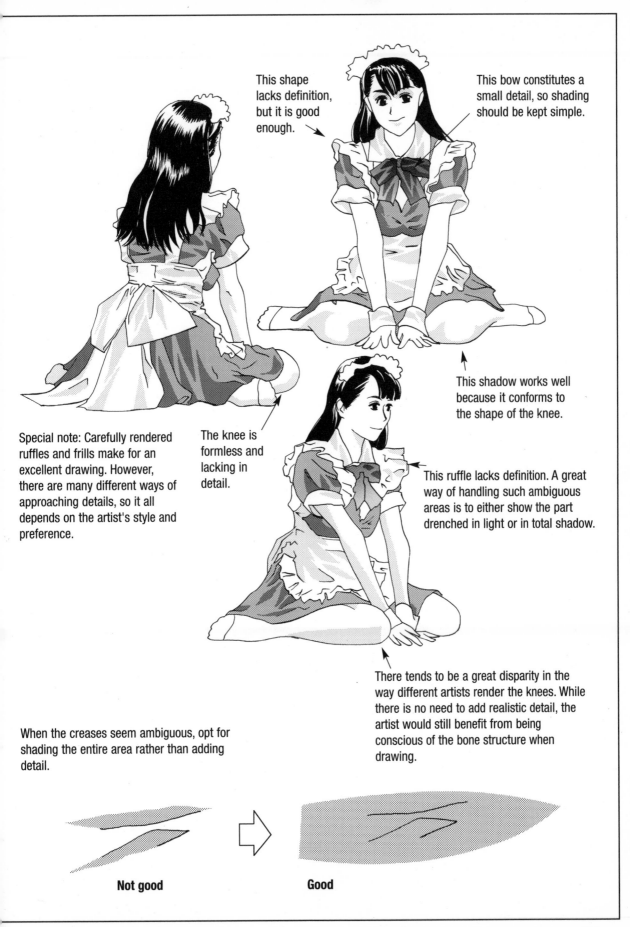

This shape lacks definition, but it is good enough.

This bow constitutes a small detail, so shading should be kept simple.

This shadow works well because it conforms to the shape of the knee.

Special note: Carefully rendered ruffles and frills make for an excellent drawing. However, there are many different ways of approaching details, so it all depends on the artist's style and preference.

The knee is formless and lacking in detail.

This ruffle lacks definition. A great way of handling such ambiguous areas is to either show the part drenched in light or in total shadow.

There tends to be a great disparity in the way different artists render the knees. While there is no need to add realistic detail, the artist would still benefit from being conscious of the bone structure when drawing.

When the creases seem ambiguous, opt for shading the entire area rather than adding detail.

Not good

Good

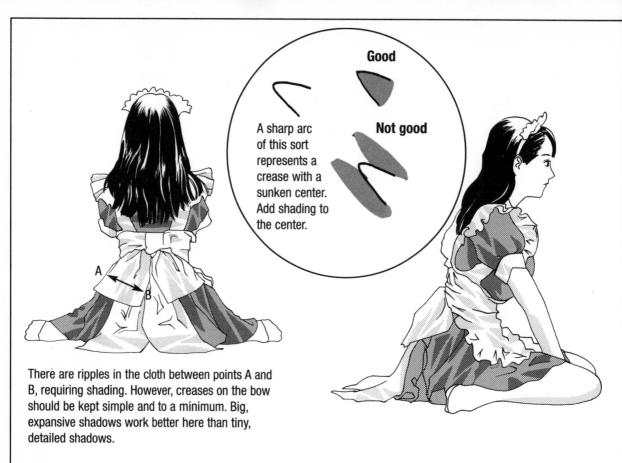

A sharp arc of this sort represents a crease with a sunken center. Add shading to the center.

Good

Not good

There are ripples in the cloth between points A and B, requiring shading. However, creases on the bow should be kept simple and to a minimum. Big, expansive shadows work better here than tiny, detailed shadows.

Why do drawn lines appear clumsy?

The most common cause of clumsily drawn lines is when the artist is not accustomed to drawing. Another is indecisiveness.

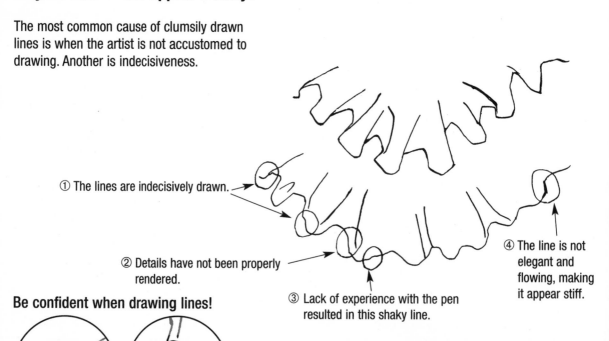

① The lines are indecisively drawn.

② Details have not been properly rendered.

③ Lack of experience with the pen resulted in this shaky line.

④ The line is not elegant and flowing, making it appear stiff.

Be confident when drawing lines!

If the structure has not been properly determined at the sketching stage, then it will be impossible to add penned lines accurately. Since there is not a lot of space between frill and ruffle folds, certainly no more dips and curves should occur.

Details have not been properly rendered.

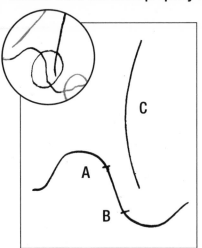

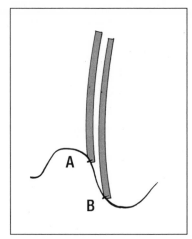

The folds of frills and ruffles tend to be tight. Line C extending from this fold needs to be clearly visible. While keeping line C from touching either point A or B does help to suggest the fabric's thickness, here the line is a little too distant.

The artist must clearly define from which fold the line extends. In this case, A seems the more natural point.

Two lines similarly separated from the cloth's edge.

Stiff lines

The above applies to curtains and pleated skirts as well as to ruffles.

Overly angular or boxy lines will cause your figure to lose its softness. Likewise, an overly curvy line takes on a frenetic appearance. Including some angular lines for accent will result in a pleasing image.

This is handled the same as a ruffle.

Unless the curtain is supposed to be blowing in a breeze, use a ruler to draw these lines.

Those with an interest in drawing or who have reached a certain level will probably feel that they are already well aware of what we have written above. However, it is quite difficult to put these ideas into practice! Even if one part of an illustration has been wonderfully rendered, other similar areas of the drawing tend to be overlooked. Why is that?

The answer is artists tend to focus on areas that attract their attention but neglect those areas that interest them less. It is important that you concentrate and direct your attention to the entire composition. Moreover, for those of you who are drawing because you are more interested in the character rather than in drawing per se, if you hope to advance your skills any further, develop a greater interest in the background and its relation to the character. For example, even if you are able to draw the maids and miko in this book perfectly, your efforts are ultimately wasted if you are unable to draw such characters in context with their natural surroundings. Therefore, if you learn to concentrate on the entire composition, your ability to produce picture-perfect manga will improve by leaps and bounds.

What Lines for Creases Mean

What part of the crease do drawn lines actually illustrate? The following figures show two parts of the crease represented by the lines.

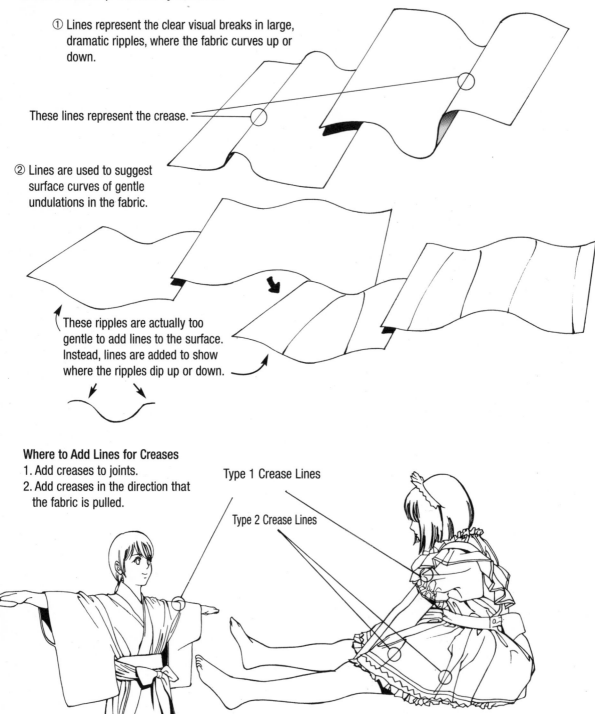

① Lines represent the clear visual breaks in large, dramatic ripples, where the fabric curves up or down.

These lines represent the crease.

② Lines are used to suggest surface curves of gentle undulations in the fabric.

These ripples are actually too gentle to add lines to the surface. Instead, lines are added to show where the ripples dip up or down.

Where to Add Lines for Creases
1. Add creases to joints.
2. Add creases in the direction that the fabric is pulled.

Type 1 Crease Lines

Type 2 Crease Lines

Points to Remember for Strategically Placing Creases
1. Be daring and confident when adding creases.
2. Add general, large lines to areas where few creases would appear, and tiny, precise lines to areas where many creases would develop.

Type 2 creases help create a certain overall mood in the artwork.

These two types of creases are extremely important and are used in illustrations throughout this book.

Miko
(Shrine Maidens)

The Basics of *Miko* Attire

A *miko* is engaged in the service of the Japanese Imperial Court or a Shinto shrine, arranging and conducting Shinto rituals and festivals. (Such servants are also called *kamiko*. The word *miko* is written in Japanese using multiple Chinese-derived kanji characters.) The *miko* also acts as an oracle or medium, channeling divine spirits, departed souls and the sacred forces or spirits of natural objects into her own body, listening to their prophesies, and is able to make her own spirit pass outside of her body. In other words, she is able to engage in extracorporeal travels, communicating with spirits, and exorcising evil spirits that have possessed others. Generally speaking, the traditional *miko* was in fact a shaman.

During the Meiji Period (1868-1912), a time in which Japan became increasingly modernized, the role of the *miko* became mostly ceremonial and for entertainment's sake, with the spiritual duties left to a subgenre of *miko* known as the *itako* (spiritual medium).

The traditional clothing worn by *miko* is called *miko shozoku*. There are minor variations in the outfits worn by members of one Shinto sect to the next; however, the style depicted in this book is the most common.

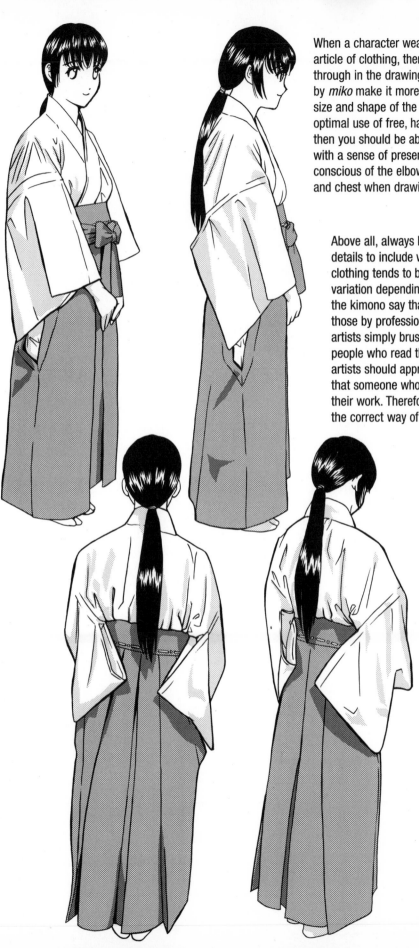

When a character wears a leotard or other formfitting article of clothing, then the body shape naturally comes through in the drawing. However, the loose robes worn by *miko* make it more difficult to achieve a sense of the size and shape of the character. However, if you make optimal use of free, hanging fabric in your drawing, then you should be able to engender your character with a sense of presence. What is critical here is to be conscious of the elbows, shoulders, knees, waist, hips and chest when drawing.

Above all, always keep in mind the overall balance and details to include when drawing *miko shozoku*. Japanese clothing tends to be rather complicated, and there is variation depending on the kimono. Those familiar with the kimono say that most drawings of kimono, even those by professional artists, tend to be inaccurate. Some artists simply brush it off with the lazy excuse, "The people who read the manga won't ever know." But artists should approach their craft with the assumption that someone who does know the difference *will* see their work. Therefore, please make every effort to learn the correct way of drawing the *miko's* dress.

First, draw a silhouette of the *miko* in her robes. Many artists skip over this step, but you will achieve better results if you start with the overall form. Once the form has been set, the rest of the composition can be drawn easily without destroying its balance. Balance tends to become lost if details are drawn first.

The *Hakama*

Many mistakenly believe the *hakama* to be similar to trousers, where the garment is divided into a right and a left leg. However, that sort of garment is actually something called either *a machidaka-hakama* (a *hakama* with a high godet) or an *umanori-hakama* (a *hakama* for riding horseback). Such *hakama* are generally worn as formal dress by men or for aikido or kendo training.

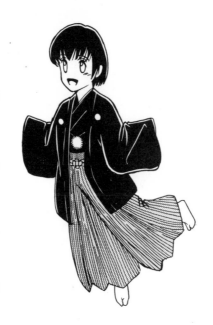

The *hakama* worn by a *miko* is called an "*andon-bakama*" (due to its resemblance to the shape of an *andon*, or Japanese paper lantern). Like a skirt, the andon-bakama is basically cylindrical in form.

The *hakama* has pleats reminiscent of the pleated skirt of a Japanese schoolgirl's uniform. More on the *hakama*'s design will be explained later in the section titled "Putting on the *Hakama*." Spreading out the *hakama* to its full width, as in the figure below, reveals quite a bit of cloth. Creases on the *hakama* in its spread state are difficult to draw, so use the examples presented here.

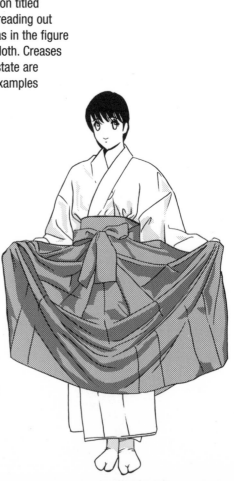

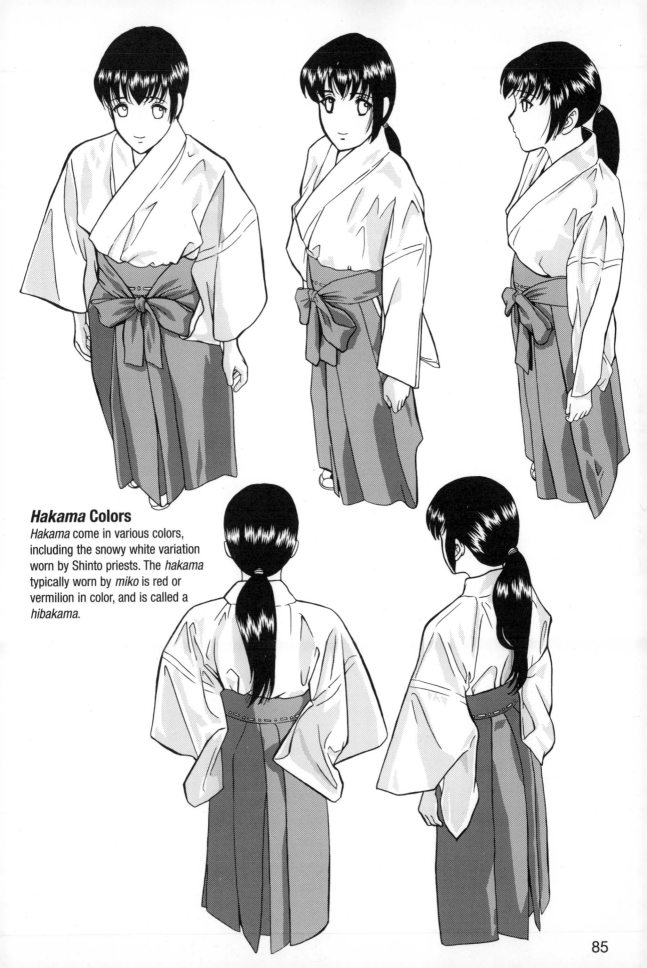

Hakama Colors

Hakama come in various colors, including the snowy white variation worn by Shinto priests. The *hakama* typically worn by *miko* is red or vermilion in color, and is called a *hibakama*.

Dressing in *Miko* Attire

The Undergarments

First, the *miko* puts on the *susoyoke* (an underskirt), and over that dons a *hadajuban* (a short, wrapped undergarment). Nowadays, a brassiere and panties are frequently worn under the *susoyake* and *hadajuban*, but the latter two constitute the traditional undergarments worn by the *miko*.

The *susoyake* is white and ends above the ankles, leaving the feet exposed.

The *susoyake* covers the lower half of the body and serves to prevent the feet from becoming entangled in the long skirt of the Japanese robe, which extends all the way to the ankles. This undergarment corresponds to the Western slip or underskirt. The *hadajuban* is made of a fabric similar to thick gauze or bleached cotton cloth. It is so lightweight that the *miko*'s figure is visible from underneath.

The *hadajuban* is short in length, ending approximately at the hips.

Hakui (white robe)

The *miko* wears a white robe called a *hakui* over the undergarments.

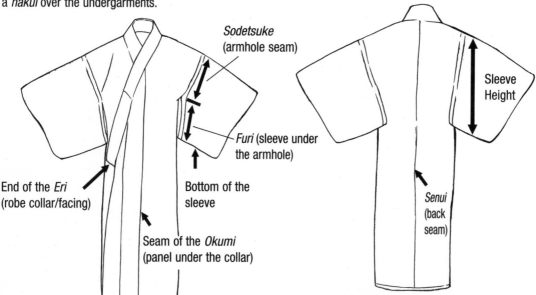

Sodetsuke (armhole seam)

Furi (sleeve under the armhole)

End of the *Eri* (robe collar/facing)

Bottom of the sleeve

Seam of the *Okumi* (panel under the collar)

Sleeve Height

Senui (back seam)

As is apparent from the illustrations above, a kimono has an *okumi* seam and a *senui* seam on the front and back, indicating its center. When the kimono is worn, these seams should fall over the axial line of the body; however, the front *okumi* seam will fall at an angle leaning toward the end of the robe facing.

Only a small part of the *okumi* seam is actually visible. Please see the following pages for reference.

The *hakui* is basically structured similarly to other kimono. However, those who are not familiar with the kimono tend to leave out the *okumi* seam or the *ohashori* (see definition below). Take care to include such essential details.

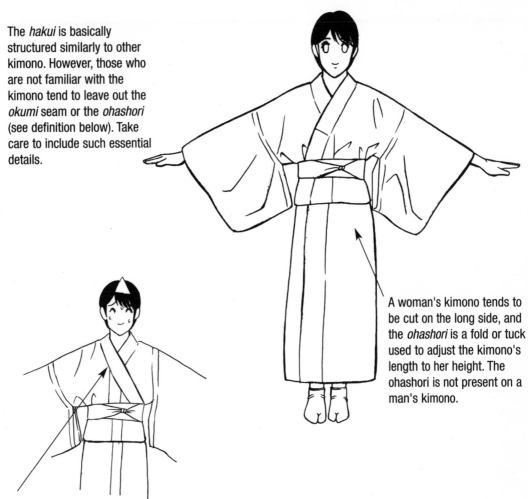

A woman's kimono tends to be cut on the long side, and the *ohashori* is a fold or tuck used to adjust the kimono's length to her height. The ohashori is not present on a man's kimono.

Caution! The kimono on this character is worn backward. The only time the right front panel of a kimono is flapped over the left panel is when the garment is on a body dressed for burial. On a living person, the left panel is always folded over the right.

Occasionally, a red collar can be seen from underneath the *miko*'s white *hakui*. This is not an actual kimono, but simply a false, removable collar, wrapped around the inside of the *hakui*'s collar and added as an accent.

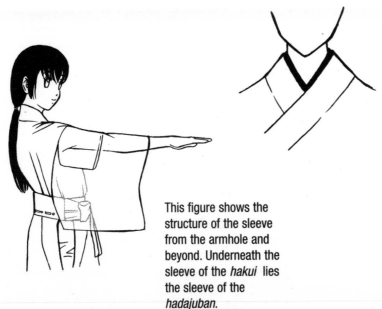

This figure shows the structure of the sleeve from the armhole and beyond. Underneath the sleeve of the *hakui* lies the sleeve of the *hadajuban*.

Putting on the *Hakama*

The *hakama* has openings on the right and left sides to help align the back and the front when dressing.

The *hakama* is fastened in the front with a sash, tied in a bow. The knot itself is situated somewhat lower than the *obi* (broad sash of a kimono). A decorative cord woven into the *obi* should also be visible.

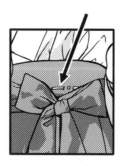

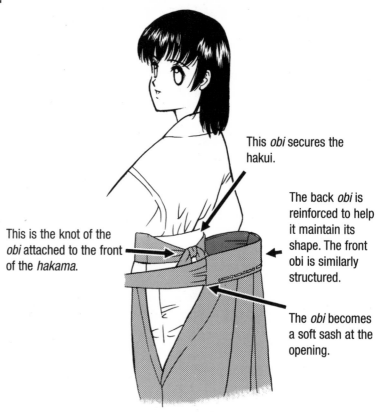

This is the knot of the *obi* attached to the front of the *hakama*.

This *obi* secures the hakui.

The back *obi* is reinforced to help it maintain its shape. The front obi is similarly structured.

The *obi* becomes a soft sash at the opening.

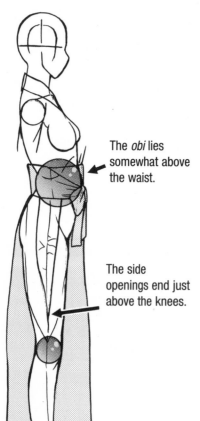

The *obi* lies somewhat above the waist.

The side openings end just above the knees.

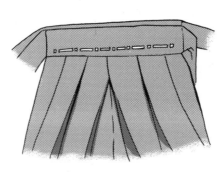

The pleats are referred to as "box pleats," and fold toward the center of the *hakama*. There are four pleats in the front and four in the back.

The decorative cord is attached to the *obi* in the following two patterns:
- One consists of seven alternating, tiny intervals, the fourth of which appears in the direct center of the hakama.
- The other consists of six wider intervals, gradually becoming smaller toward the center of the *hakama* and then broadening again.

The illustration above is a close-up of the cord. It is woven into the obi of the *hakama* similar to the way a belt weaves in and out of the belt loops of pants.

Adjusting Garments

There is a proper way of wearing a kimono to make it appear attractive. The kimono can become loose or unkempt from such common actions as raising or gesturing with the arm, so the garment often needs adjustment.

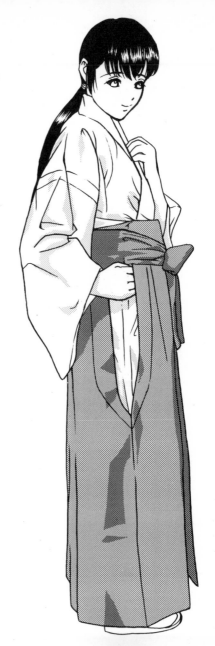

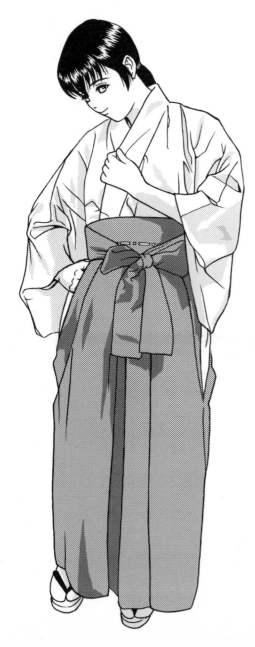

The right facing can be easily pulled or adjusted by slipping the hand through the very wide *sodetsuke* (armhole seam).

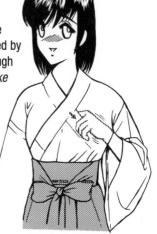

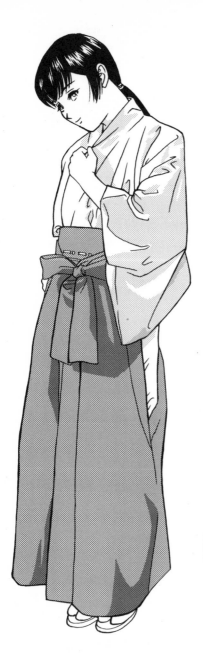

Give careful consideration
when determining areas
where light meets shadow.
This will give the arm
weight and volume.

The large shadow
appearing on the character
to the right is intrinsic to
the expansive sleeve of the
kimono. It looks impressive
and works extremely well in
key panels.

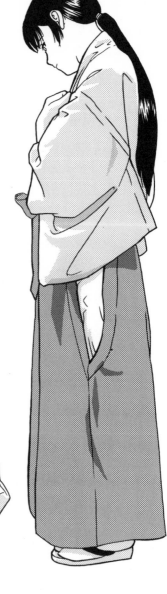

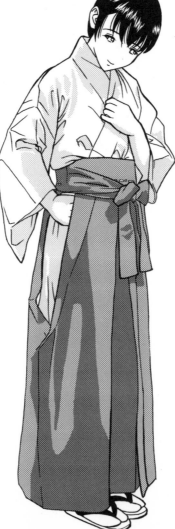

More About Adjusting Garments

When the *hakama* has been worn over an extended period of time, it begins to appear untidy. This can be fixed by adjusting the position of the *obi*.

The back of the *furi* (hanging portion of the kimono sleeve) is open, indicative of its design as woman's clothing. Conversely, the pocket of the *furi* is closed on a man's kimono.

This shadow results from the dangling sleeve.

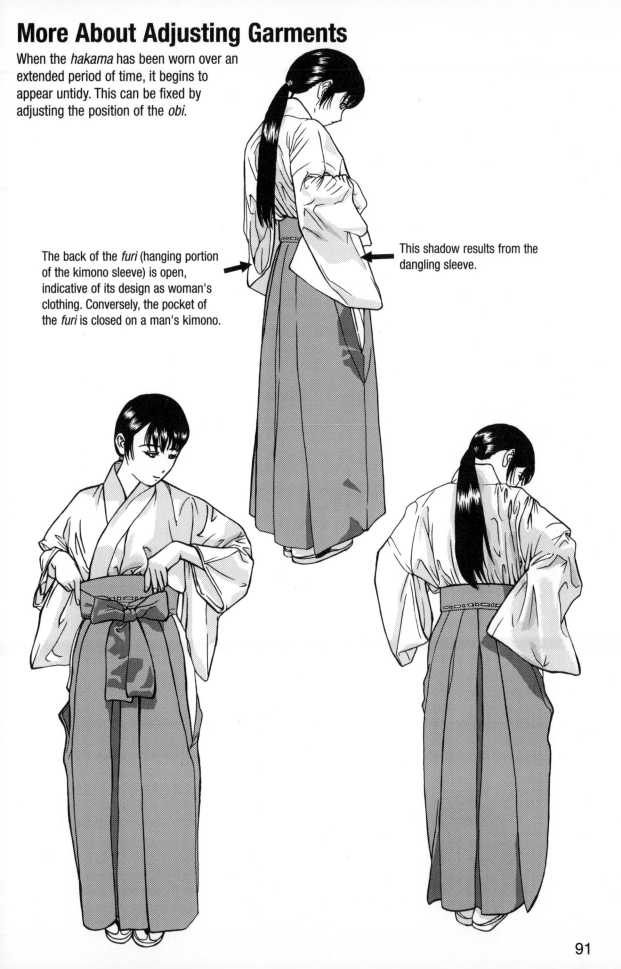

The *Chihaya*

The *chihaya* is an outer robe worn by *miko* when performing a traditional dance at a festival or other ceremony. The garment presented in this book is a simplified version. *Chihaya* come in two general styles: pure white and patterned.

Openings tend to be included in the shoulders of *chihaya* in manga and anime; however, such openings are actually found in *kariginu* (traditional hunting dress) or *suikan* (man's outer robe).

The *kariginu* was part of the ordinary dress of Japanese nobility during the Heian Period (794-1185). Beginning in the Kamakura Period (1186-1333), the *kariginu* became an article of formal wear for both nobles and members of the samurai class. Today, the garment is worn primarily by Shinto priests. The *suikan* was part of the everyday clothing worn by courtiers and dignitaries and the formal dress of juvenile nobles who had not yet undergone their coming-of-age ceremony. In the Kamakura Period, the *suikan* was transformed into the formal attire of the samurai.

The illustration to the left shows a *shirabyoshi* (female dancer in male attire) wearing an *eboshi* (formal headwear of courtiers) and suikan. The word *shirabyoshi* originally referred to traditional musical performances that were popular during the late Heian Period. However, the word also refers to a female dancer dressed in men's clothing. There have been accounts of *miko* who for some reason lost their divine or priestess abilities, causing them to leave the shrine and earn money performing in the arts.

The roles of these former *miko* spanned the spectrum of entertainment. Some were even said to have prostituted themselves. Others, however, remained virtuous, including Shizukagozen (a famed *miko* who lived during the late Heian and early Kamakura periods), despite the fact that she had become the concubine of Japanese military leader and tragic hero Minamoto Yoshitsune.

Those *shirabyoshi* who succumbed to prostitution were believed to have lost their spiritual powers along with their virginity, and therefore unable to resume their former positions as *miko*. However, depending on the *miko*'s lineage, some were believed to retain their powers even after having given birth and and were said to have received from or passed along powers to their offspring. Therefore, *shirabyoshi* and *miko* can be considered closely linked occupations.

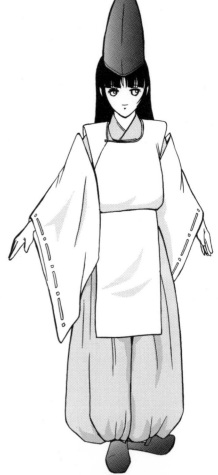

This figure is dressed as a *kannushi* (Shinto priest or shrine guardian) and wearing *kariginu*. The occupation of *kannushi* can be held by both men and women. Although the *kannushi* is different from the *miko*, the *kariginu* is still acceptable dress for a female character.

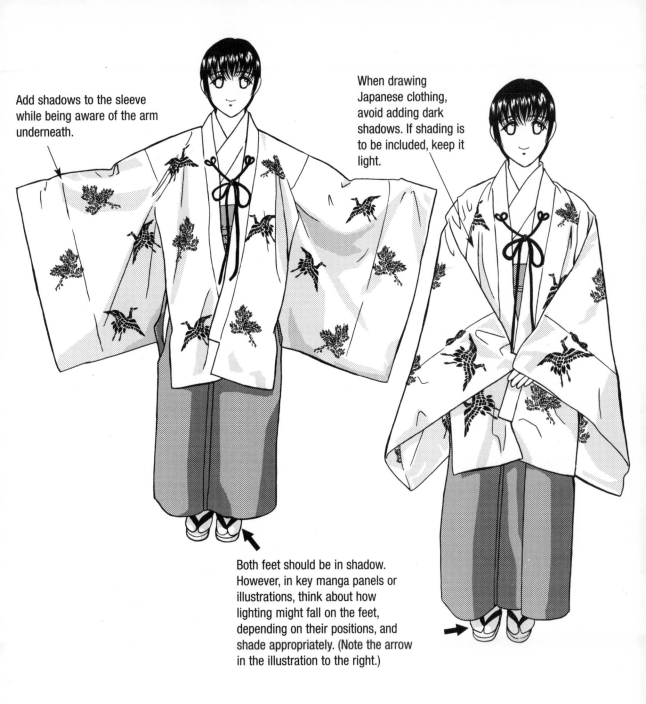

Add shadows to the sleeve while being aware of the arm underneath.

When drawing Japanese clothing, avoid adding dark shadows. If shading is to be included, keep it light.

Both feet should be in shadow. However, in key manga panels or illustrations, think about how lighting might fall on the feet, depending on their positions, and shade appropriately. (Note the arrow in the illustration to the right.)

The *chihaya* featured on this page are adorned with these two patterns.

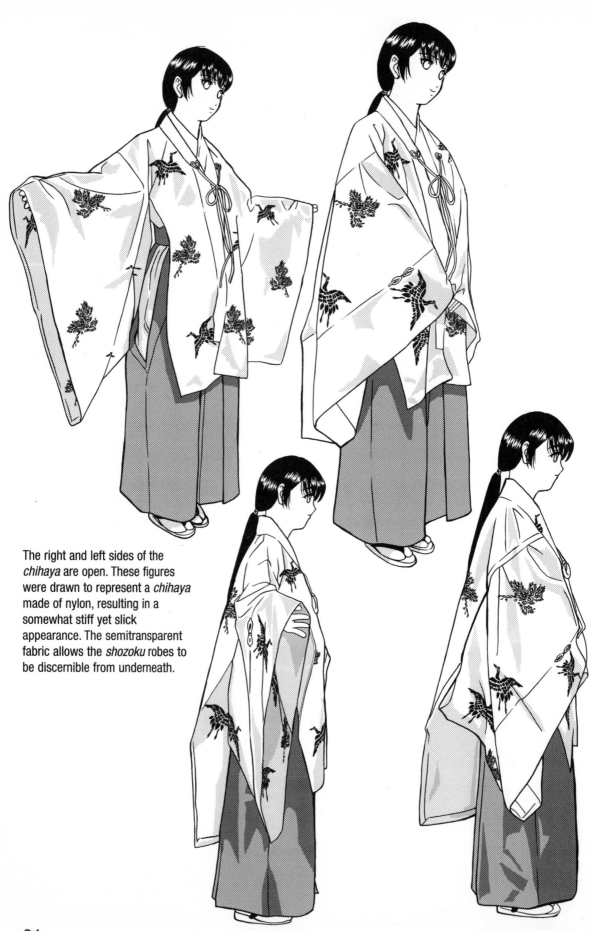

The right and left sides of the *chihaya* are open. These figures were drawn to represent a *chihaya* made of nylon, resulting in a somewhat stiff yet slick appearance. The semitransparent fabric allows the *shozoku* robes to be discernible from underneath.

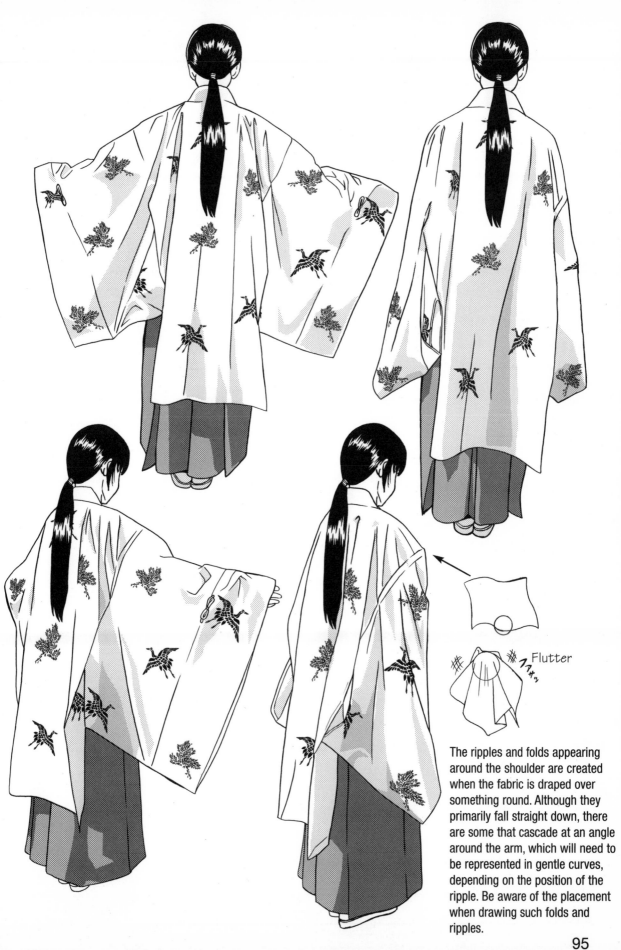

Flutter

The ripples and folds appearing around the shoulder are created when the fabric is draped over something round. Although they primarily fall straight down, there are some that cascade at an angle around the arm, which will need to be represented in gentle curves, depending on the position of the ripple. Be aware of the placement when drawing such folds and ripples.

Hair Adornments

Miko may wear hair adornments such as those illustrated in below. The hair is wrapped in *washi* (handmade paper) and then tied with a ceremonial red and white cord called a *mizuhiki.* Such ornamentation is worn by ordained *miko*. Those without bound hair are called *jokin* (apprentice), young women who basically serve as part-time assistants.

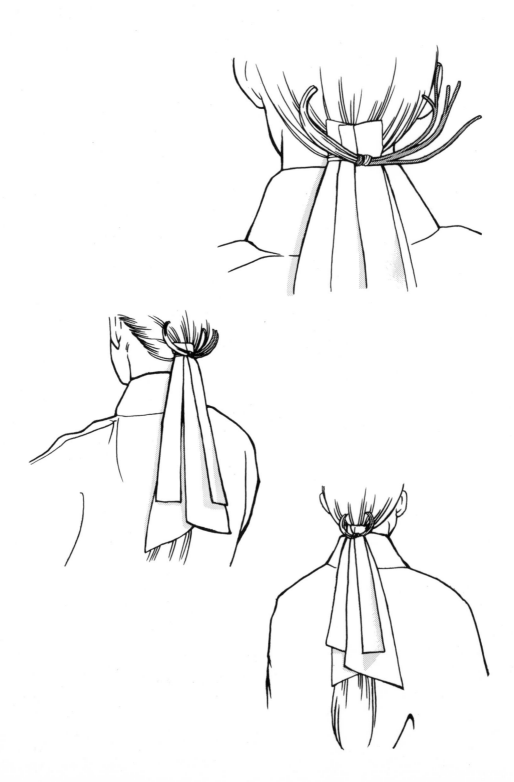

Zori

The *zori* (Japanese sandals) pictured here have been drawn as if made of plastic and thus have a slick appearance. Traditional *zori* are made of woven straw or rush stalks and bamboo bark and have a texture similar to *tatami* (straw floor mats).

Zori are oblong in design, and those worn by women are intended to allow the foot to hang slightly over the sole.

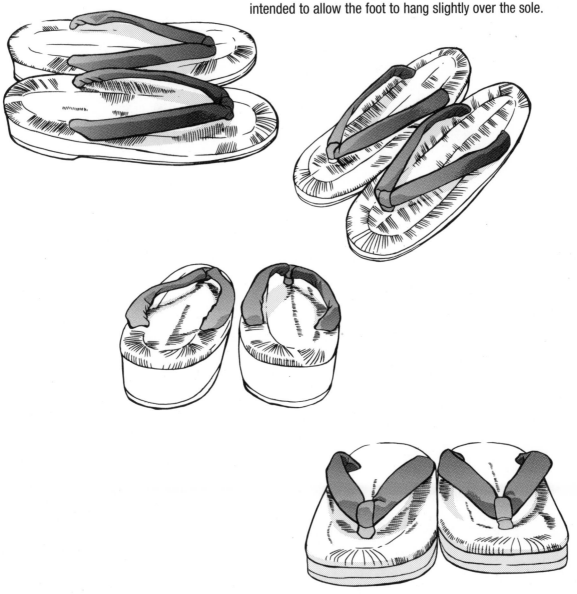

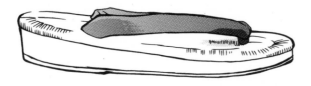

Kashiwade (Ceremonial Clapping)

Devotional worship of Shinto deities and spirits includes ceremonial clapping called *kashiwade*. This practice demonstrates reverence toward the spirits and also carries the meaning of respect toward others. *Kashiwade* takes several forms, depending on the particular shrine. One version consists of two bows and three claps followed by one bow; another consists of eight claps (*yahirate*); and a third version (*shinobite*) involves quietly touching the four fingers of the right hand (but not the thumb) to the palm of the left.

Ceremonial clapping is never exaggerated or loud, but instead gentle and unaffected.

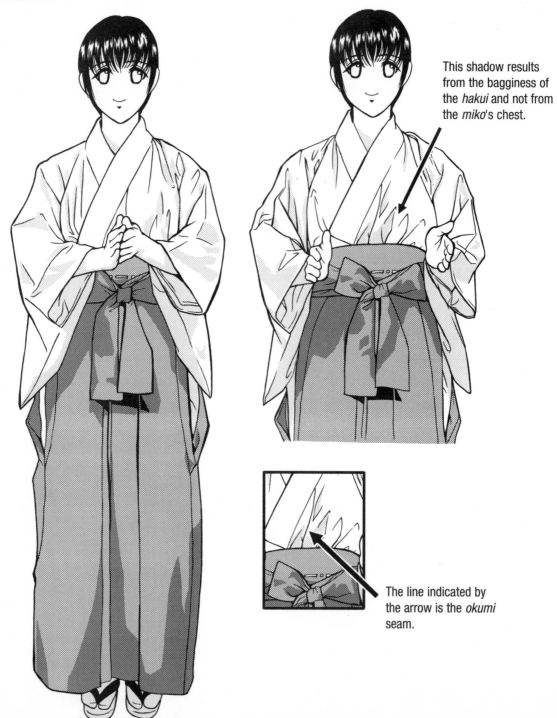

This shadow results from the bagginess of the *hakui* and not from the *miko*'s chest.

The line indicated by the arrow is the *okumi* seam.

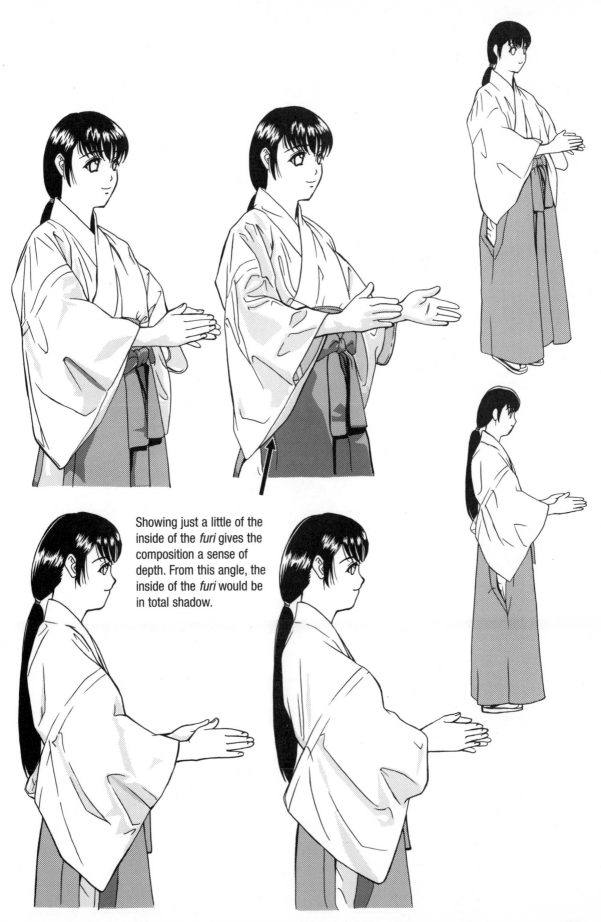

Showing just a little of the inside of the *furi* gives the composition a sense of depth. From this angle, the inside of the *furi* would be in total shadow.

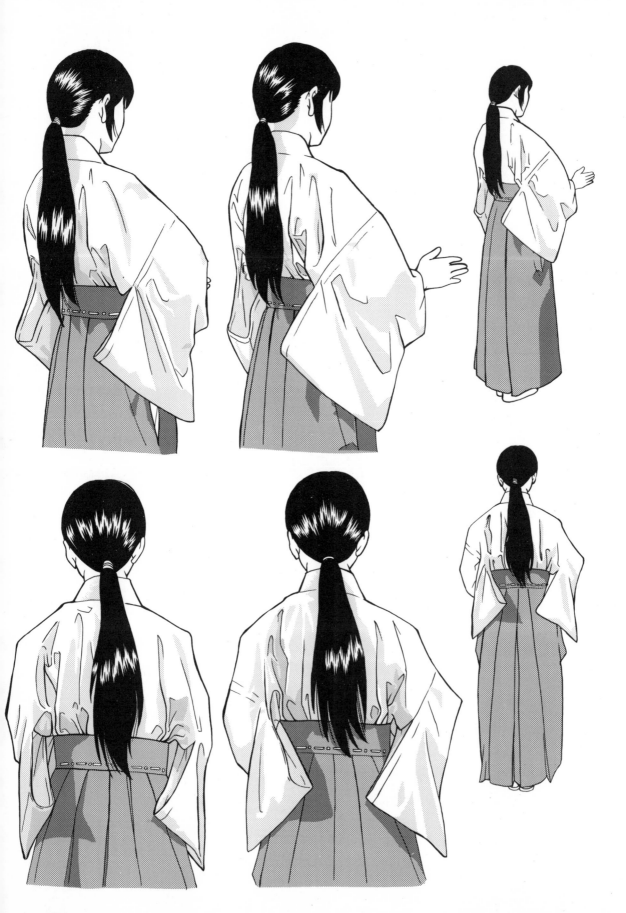

Hai (Devotional Bowing)

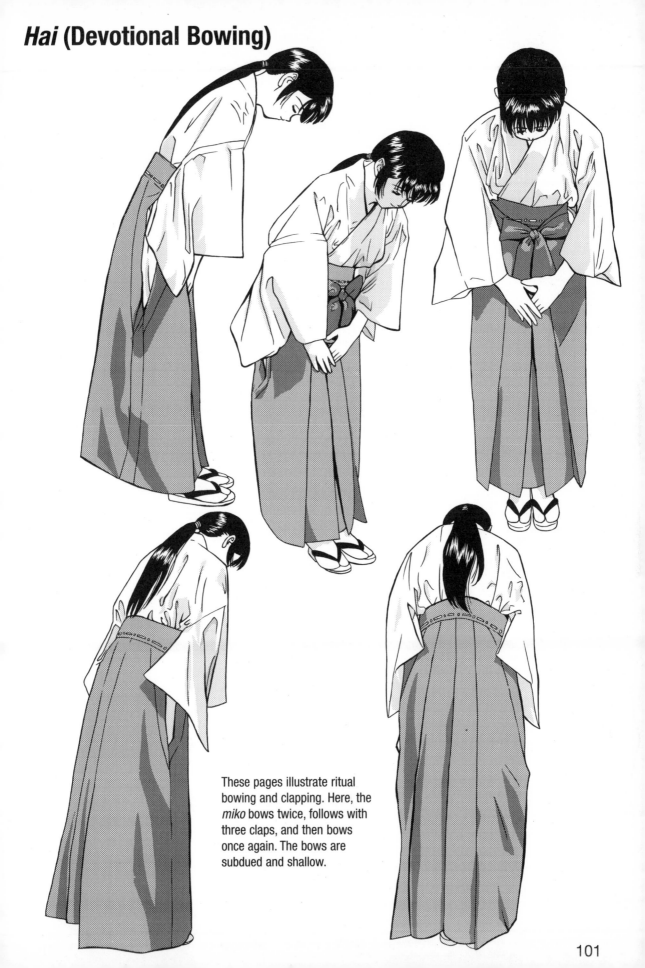

These pages illustrate ritual bowing and clapping. Here, the *miko* bows twice, follows with three claps, and then bows once again. The bows are subdued and shallow.

Holding the Sleeve

When intending to reach for or grab an object, the long sleeve can be a nuisance. Therefore, whenever extending the arm, the sleeve is first grasped with the opposite hand.

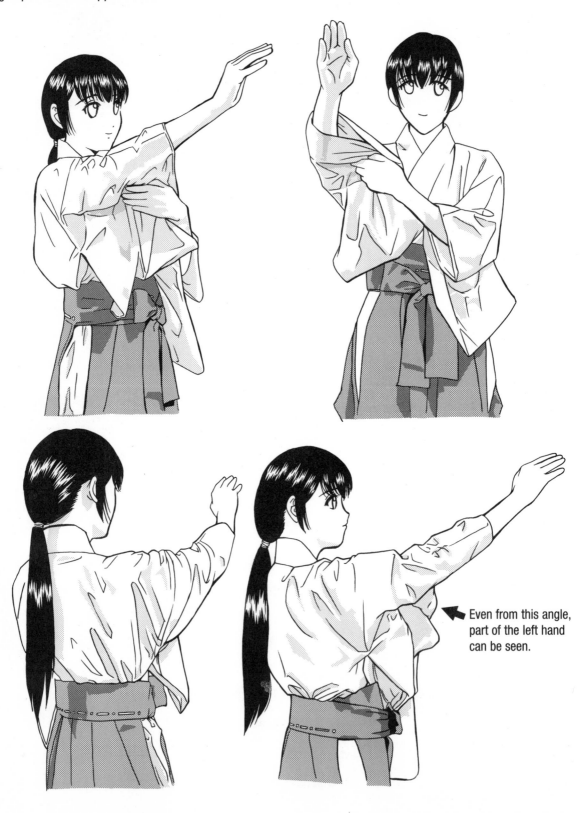

Even from this angle, part of the left hand can be seen.

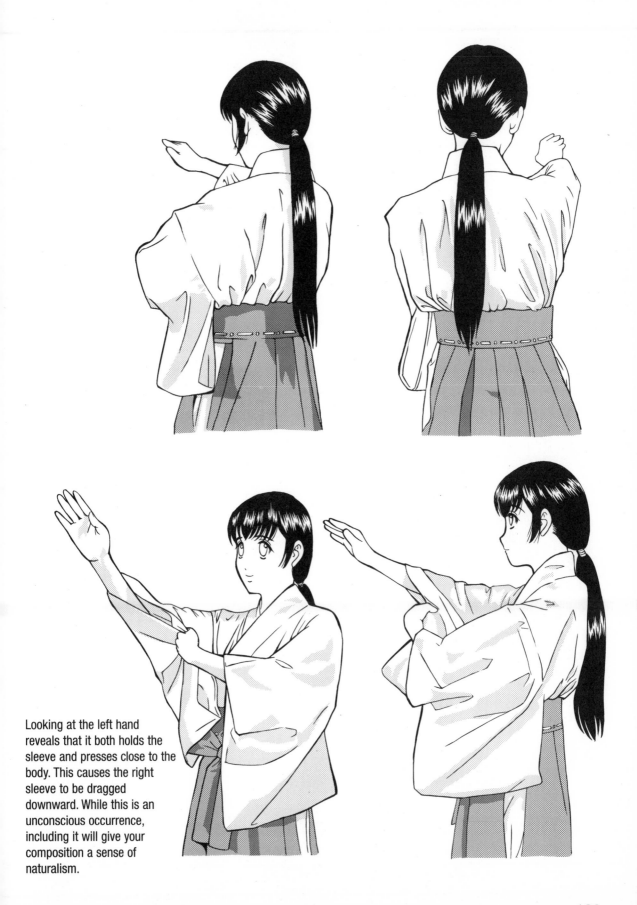

Looking at the left hand reveals that it both holds the sleeve and presses close to the body. This causes the right sleeve to be dragged downward. While this is an unconscious occurrence, including it will give your composition a sense of naturalism.

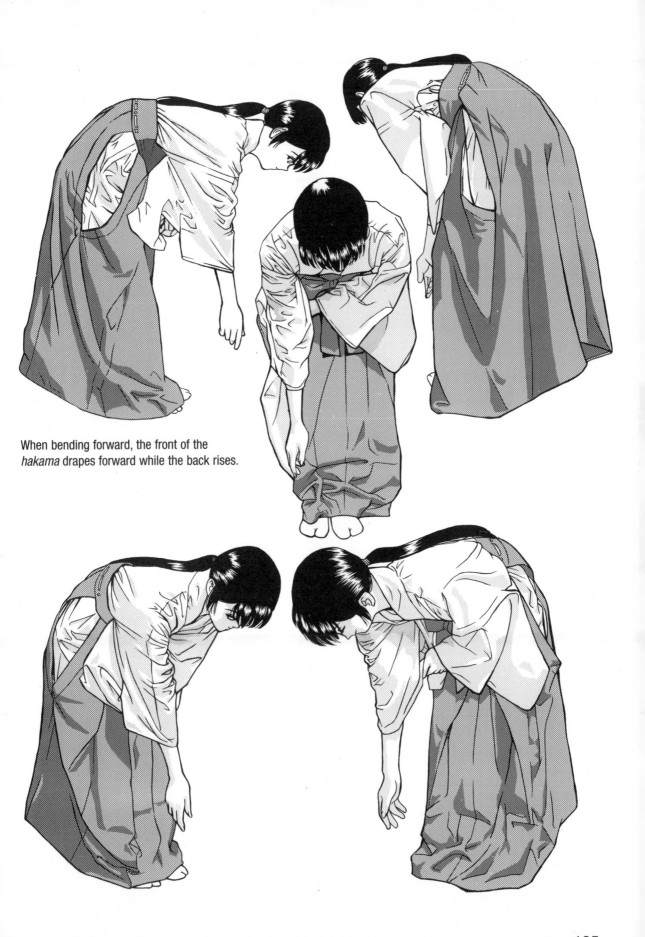

When bending forward, the front of the
hakama drapes forward while the back rises.

Turning the Body

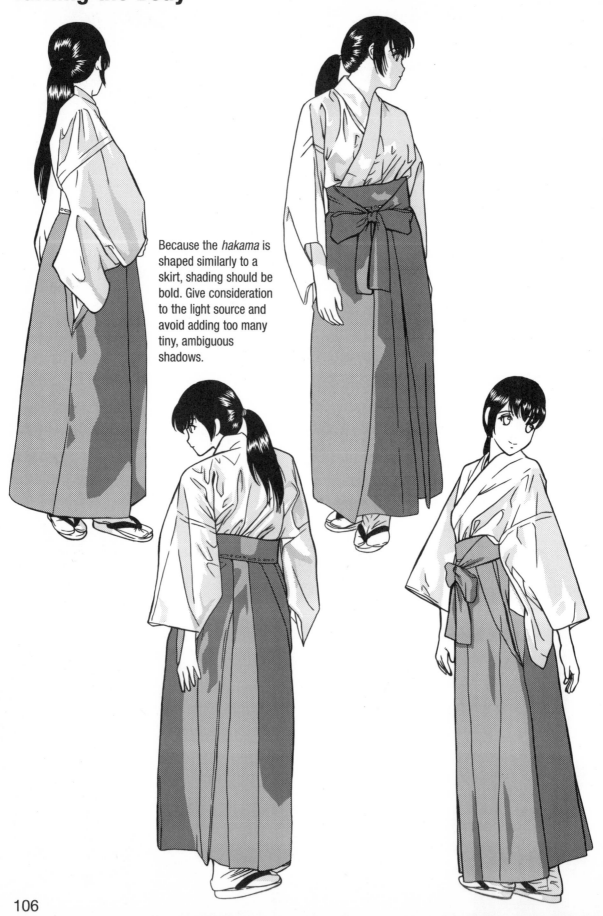

Because the *hakama* is shaped similarly to a skirt, shading should be bold. Give consideration to the light source and avoid adding too many tiny, ambiguous shadows.

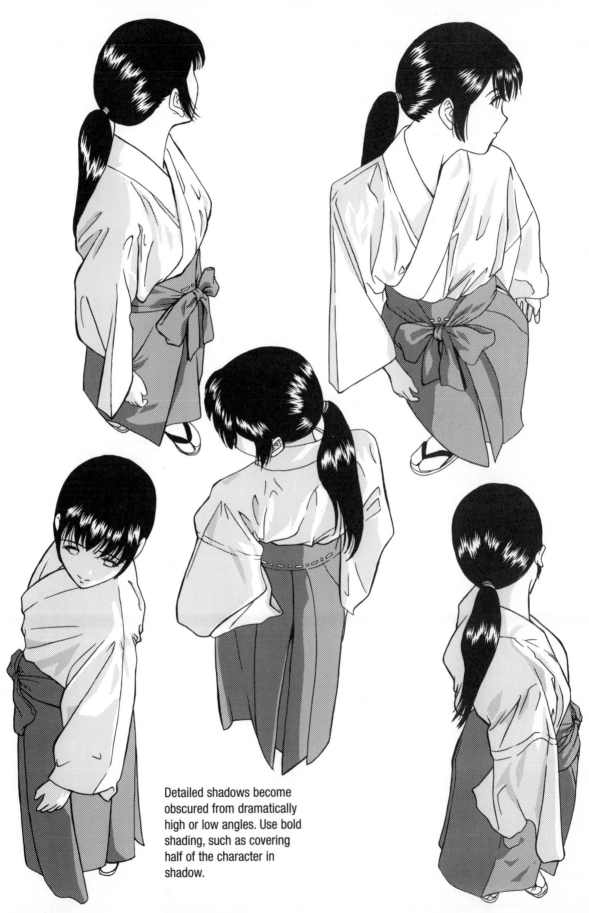

Detailed shadows become
obscured from dramatically
high or low angles. Use bold
shading, such as covering
half of the character in
shadow.

Both Arms Raised Forward

Note changes around the shoulders and the presence of creases when both arms are raised.

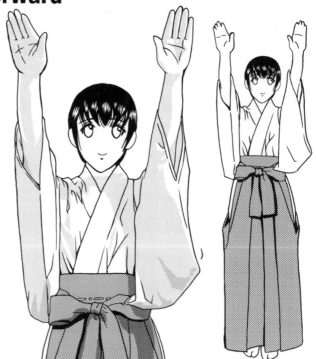

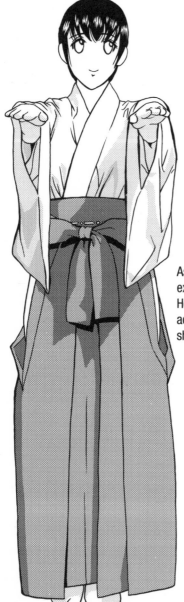

As suggested in the illustration above, shadows appear on the sleeves and extend to the body, in relation to the pose and the position of the light source. However, depending on the compositional circumstances, you may want to avoid adding expansive shadows. In such a case, either minimize the size of the shadows or adjust the pose to one that would naturally require less shading.

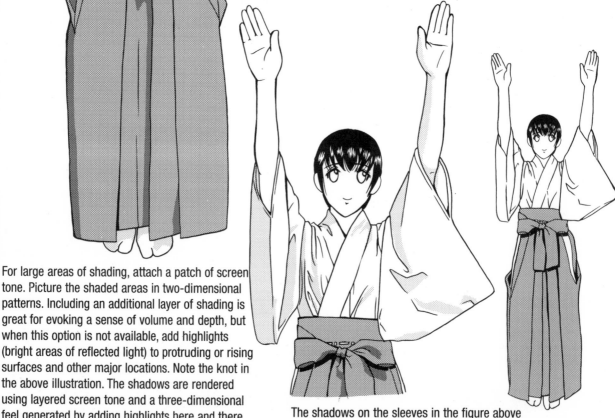

For large areas of shading, attach a patch of screen tone. Picture the shaded areas in two-dimensional patterns. Including an additional layer of shading is great for evoking a sense of volume and depth, but when this option is not available, add highlights (bright areas of reflected light) to protruding or rising surfaces and other major locations. Note the knot in the above illustration. The shadows are rendered using layered screen tone and a three-dimensional feel generated by adding highlights here and there. The key point here is to maintain the overall form of the large shadow.

The shadows on the sleeves in the figure above do not extend to the trunk. Instead, they appear to fall back.

The arm passes through the armhole, creating an almost cylindrical shape inside. The *furi* (hanging part of the sleeve) is, in contrast, practically flat. The height of the sleeve is measured as the distance from the top of the armhole to the bottom of the *furi*. While the armhole and the *furi* form a single unit, conceive of them as separate pieces when drawing.

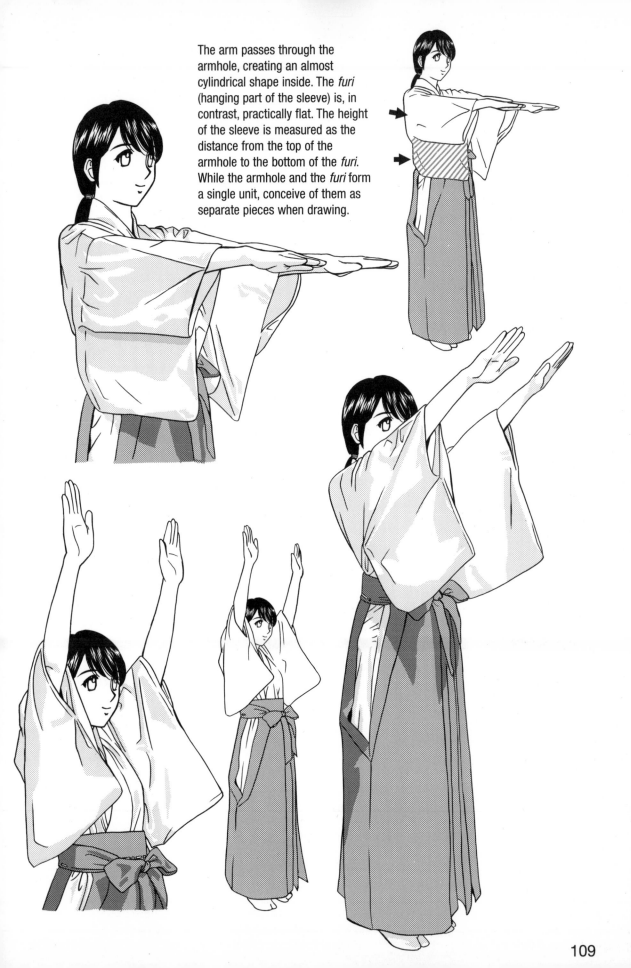

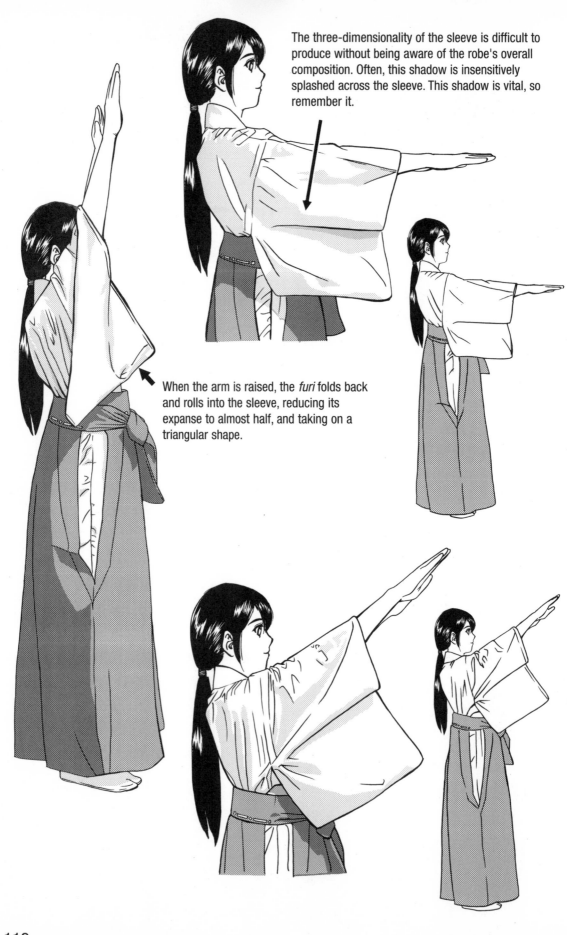

The three-dimensionality of the sleeve is difficult to produce without being aware of the robe's overall composition. Often, this shadow is insensitively splashed across the sleeve. This shadow is vital, so remember it.

When the arm is raised, the *furi* folds back and rolls into the sleeve, reducing its expanse to almost half, and taking on a triangular shape.

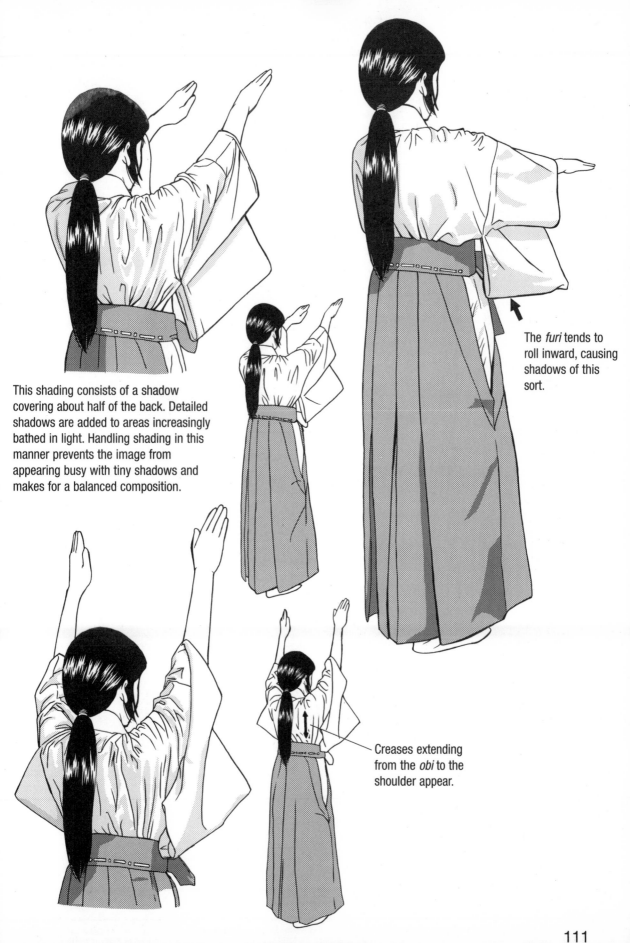

This shading consists of a shadow covering about half of the back. Detailed shadows are added to areas increasingly bathed in light. Handling shading in this manner prevents the image from appearing busy with tiny shadows and makes for a balanced composition.

The *furi* tends to roll inward, causing shadows of this sort.

Creases extending from the *obi* to the shoulder appear.

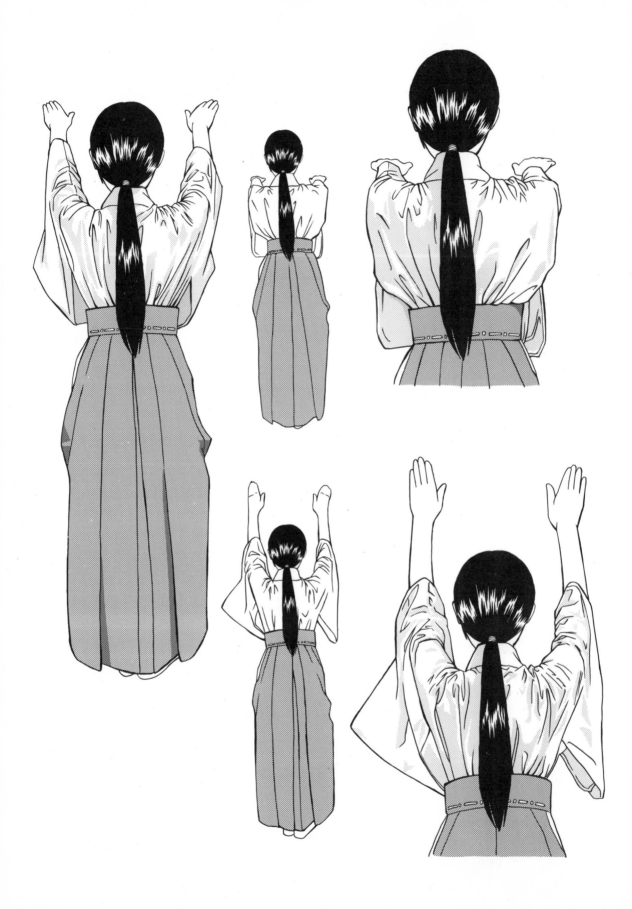

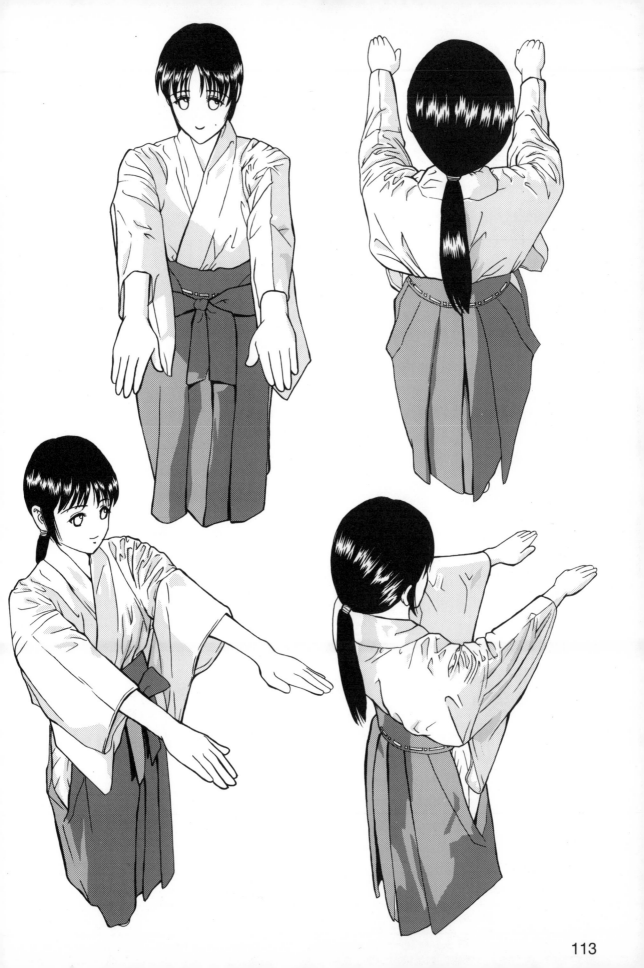

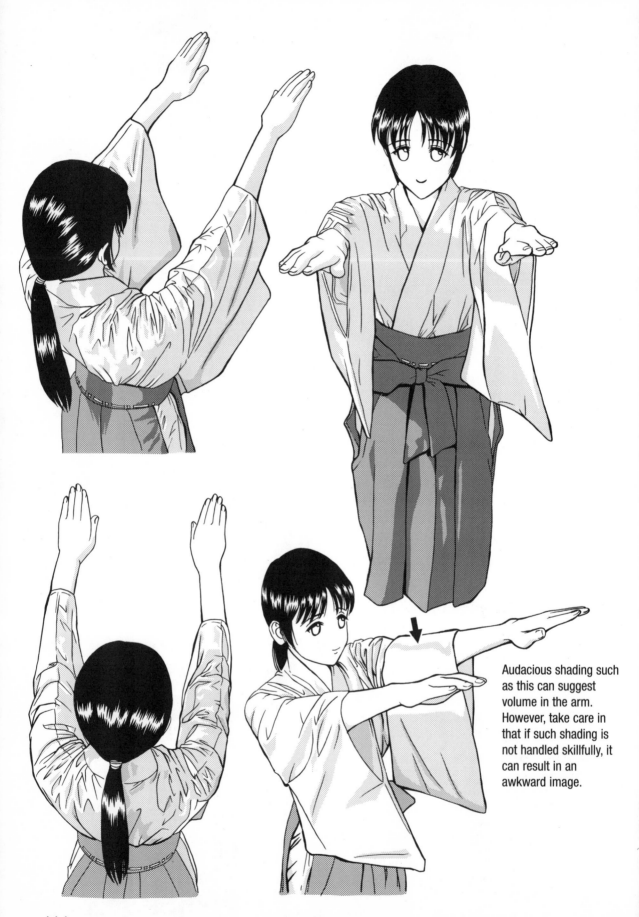

Audacious shading such as this can suggest volume in the arm. However, take care in that if such shading is not handled skillfully, it can result in an awkward image.

Look at the figures on this page and note how the *hakui* hugs closely to the body such that the contours around the shoulder are apparent when the arms are raised.

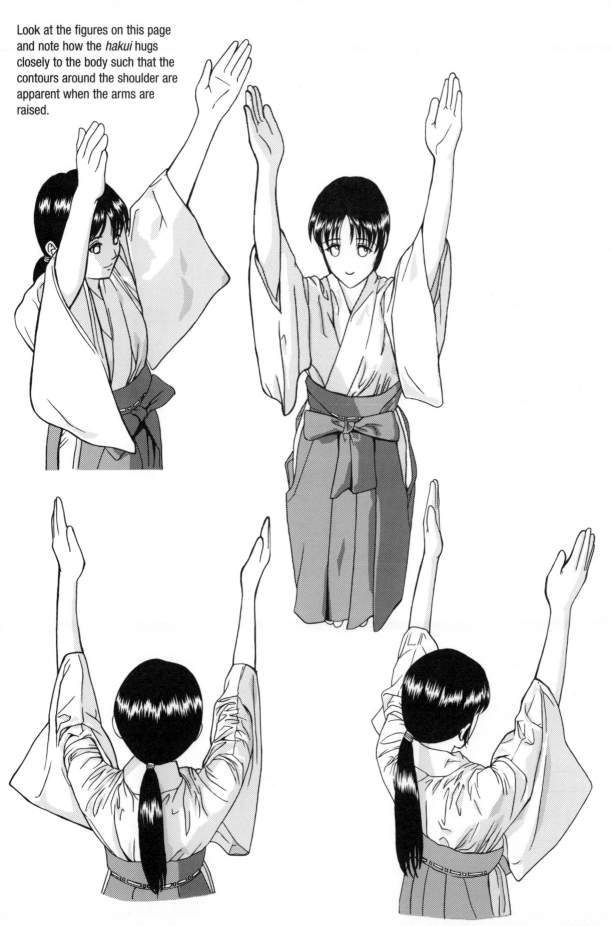

Both Arms Raised to the Side

Although both arms are still being raised, the visual differences of raising the arms to the side versus forward are great.

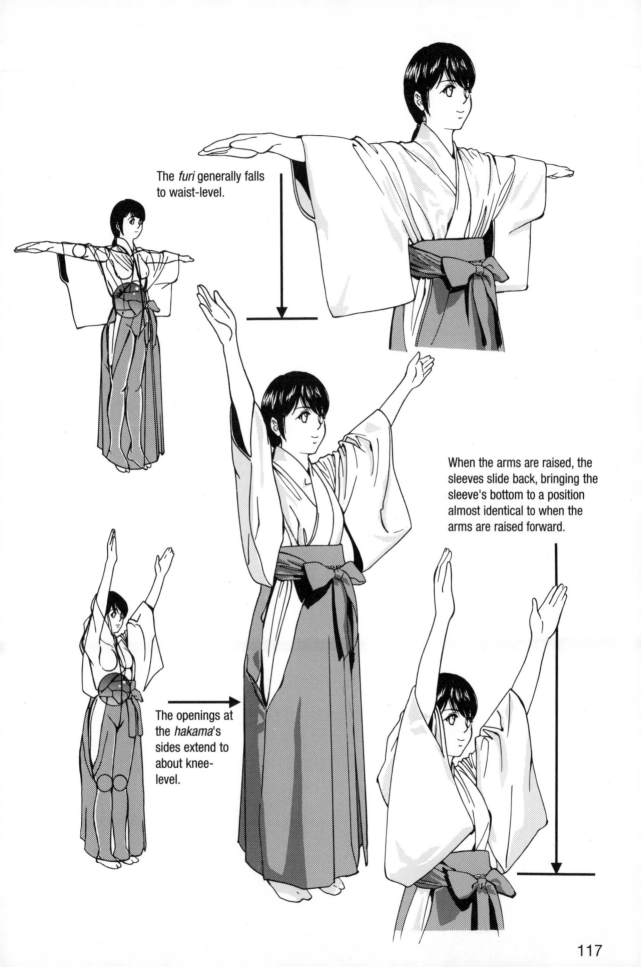

The *furi* generally falls to waist-level.

When the arms are raised, the sleeves slide back, bringing the sleeve's bottom to a position almost identical to when the arms are raised forward.

The openings at the *hakama*'s sides extend to about knee-level.

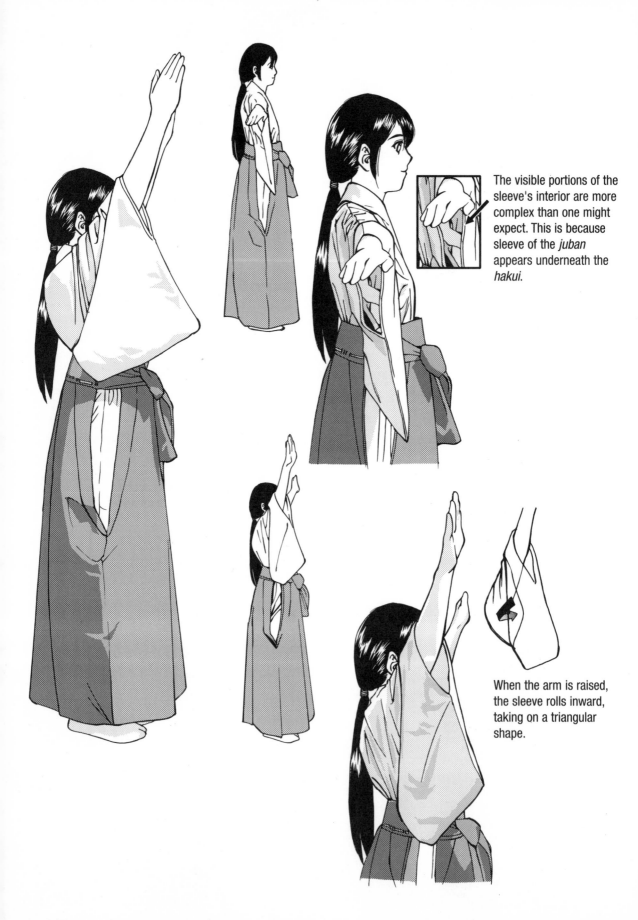

The visible portions of the sleeve's interior are more complex than one might expect. This is because sleeve of the *juban* appears underneath the *hakui*.

When the arm is raised, the sleeve rolls inward, taking on a triangular shape.

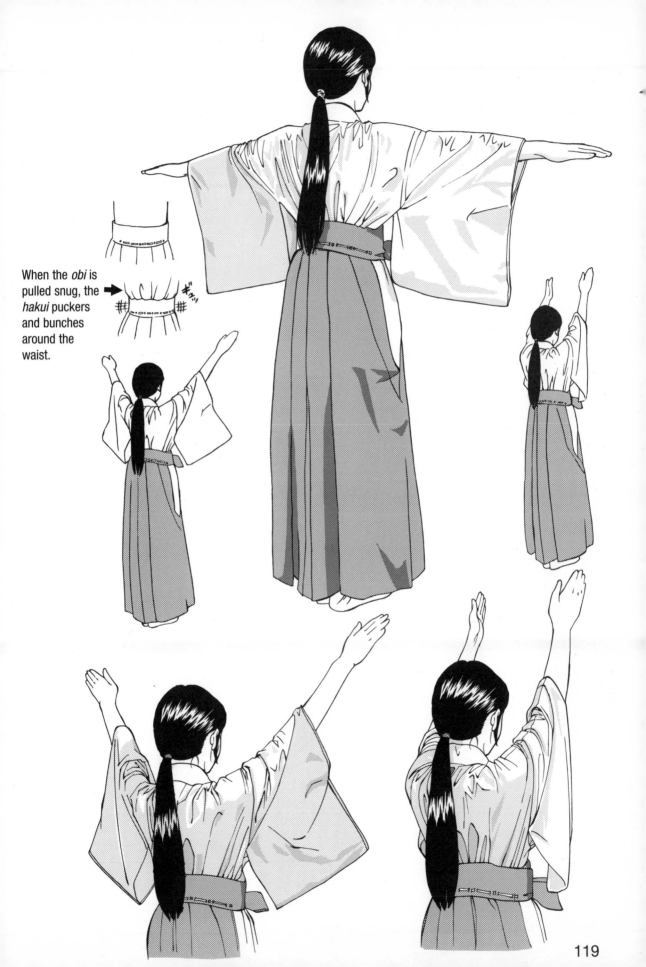

When the *obi* is pulled snug, the *hakui* puckers and bunches around the waist.

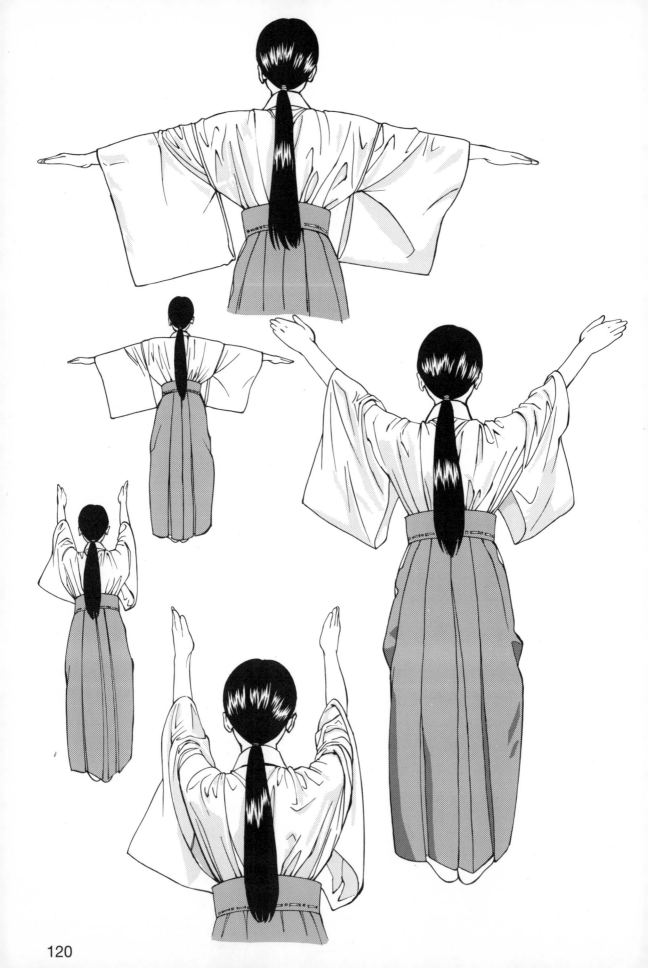

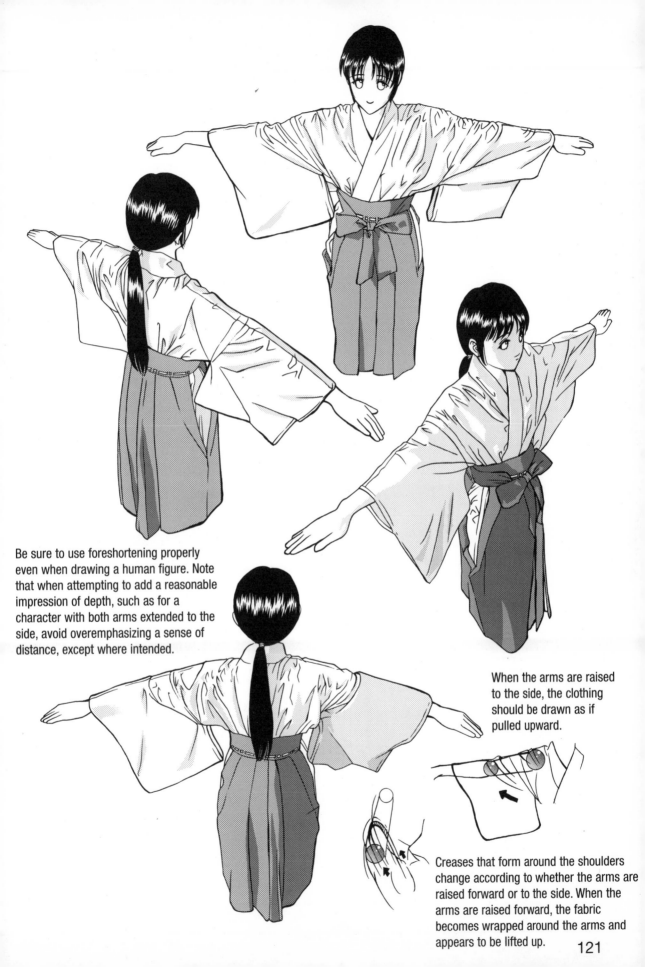

Be sure to use foreshortening properly even when drawing a human figure. Note that when attempting to add a reasonable impression of depth, such as for a character with both arms extended to the side, avoid overemphasizing a sense of distance, except where intended.

When the arms are raised to the side, the clothing should be drawn as if pulled upward.

Creases that form around the shoulders change according to whether the arms are raised forward or to the side. When the arms are raised forward, the fabric becomes wrapped around the arms and appears to be lifted up.

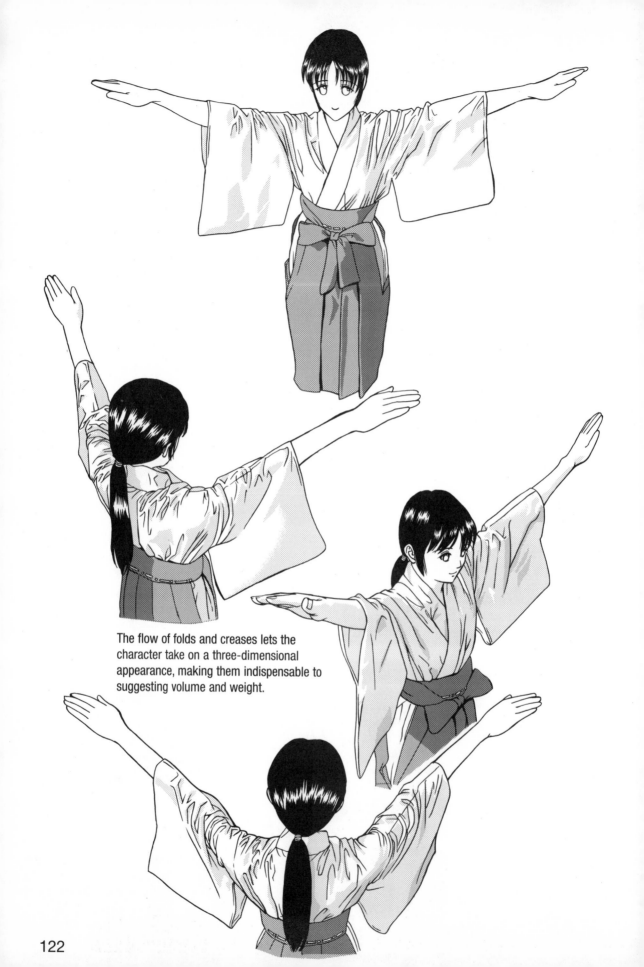

The flow of folds and creases lets the character take on a three-dimensional appearance, making them indispensable to suggesting volume and weight.

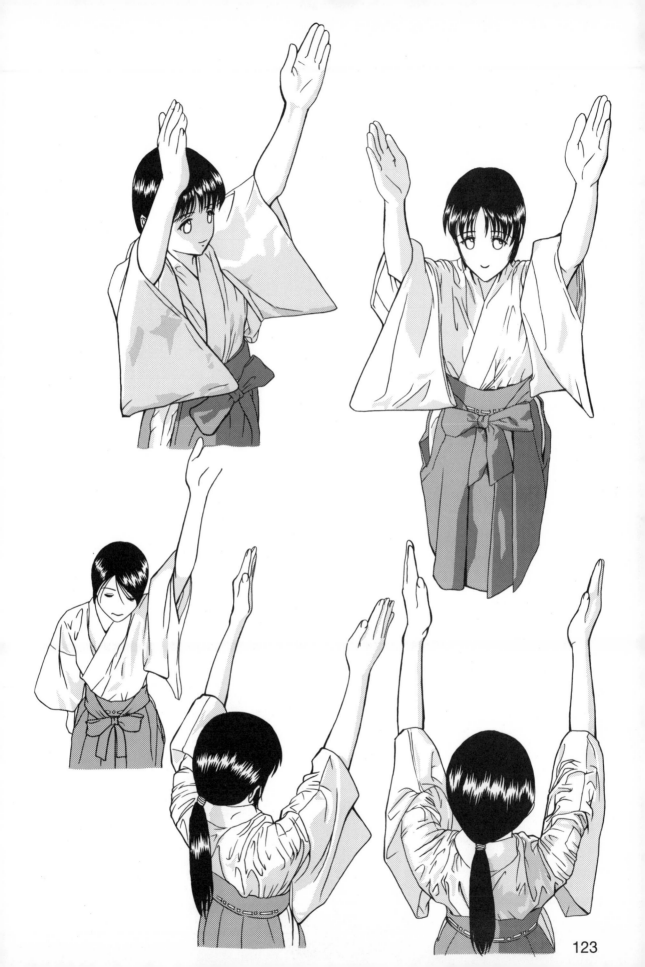

One Arm Raised Forward

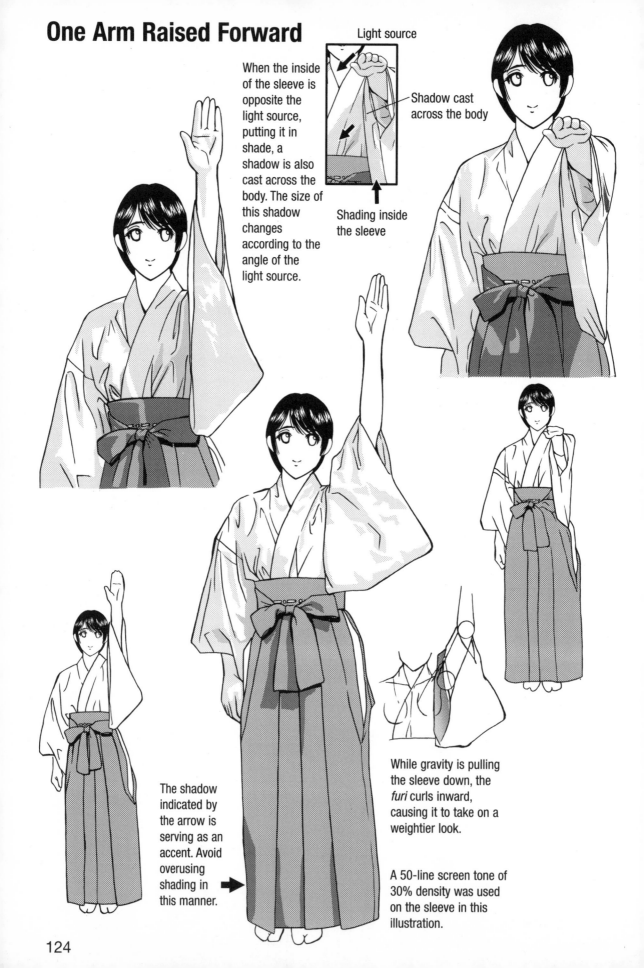

Light source

When the inside of the sleeve is opposite the light source, putting it in shade, a shadow is also cast across the body. The size of this shadow changes according to the angle of the light source.

Shadow cast across the body

Shading inside the sleeve

The shadow indicated by the arrow is serving as an accent. Avoid overusing shading in this manner.

While gravity is pulling the sleeve down, the *furi* curls inward, causing it to take on a weightier look.

A 50-line screen tone of 30% density was used on the sleeve in this illustration.

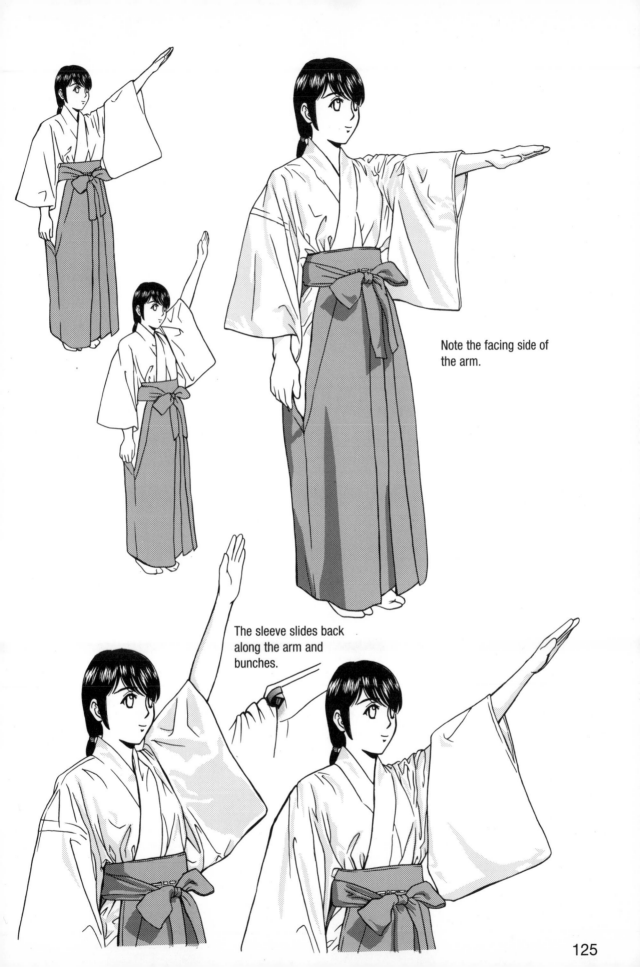

Note the facing side of the arm.

The sleeve slides back along the arm and bunches.

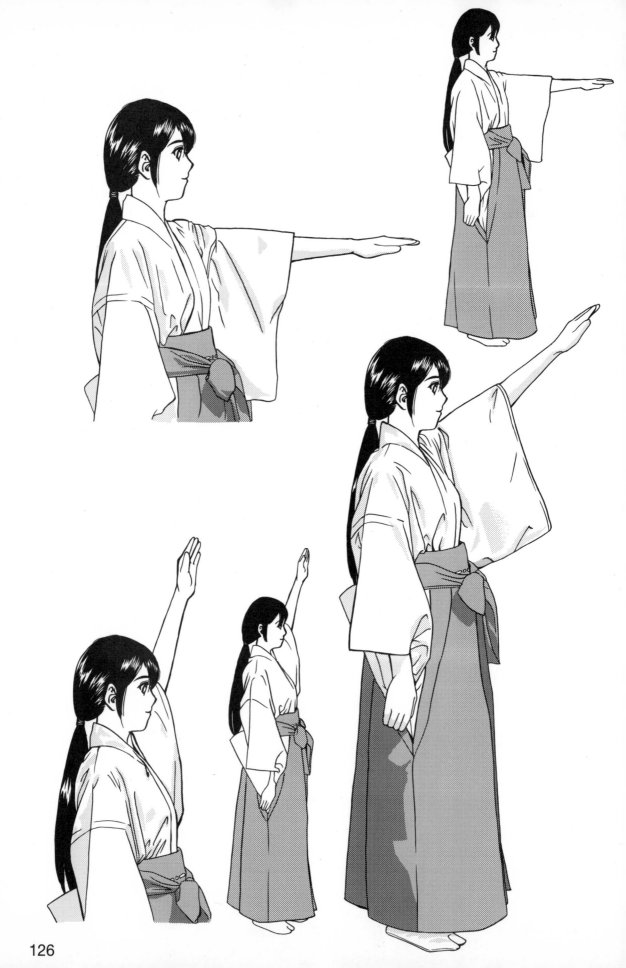

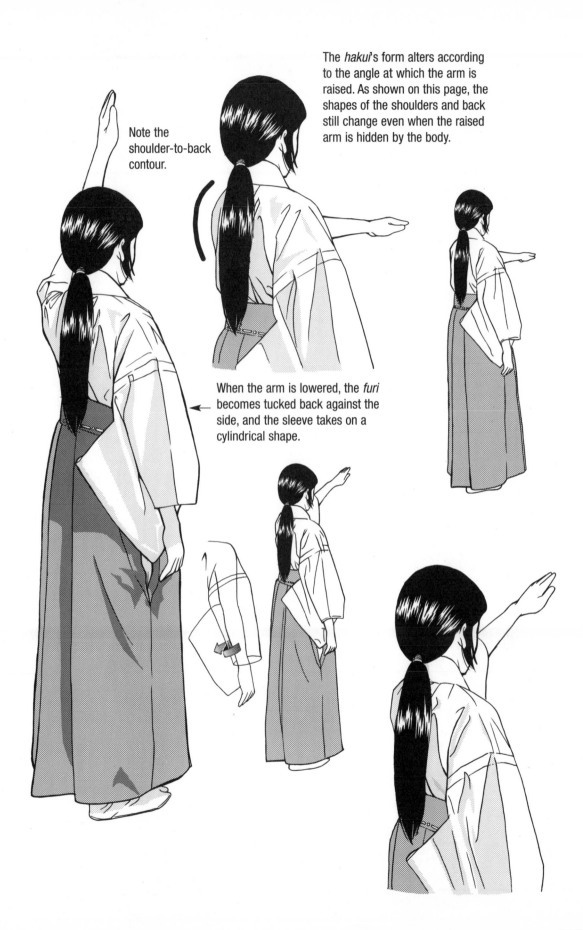

Note the shoulder-to-back contour.

The *hakui*'s form alters according to the angle at which the arm is raised. As shown on this page, the shapes of the shoulders and back still change even when the raised arm is hidden by the body.

When the arm is lowered, the *furi* becomes tucked back against the side, and the sleeve takes on a cylindrical shape.

Giving Volume to Creases and Folds

Figure A shows the typical curved line used for a crease. We do not have a sense of the crease's depth, raising the question of how to achieve such an effect. One way is to attach screen tone to the side of the crease, creating a three-dimensional look. Another way is to draw a curve as shown in Figure B, where the first line starts at Point A and then a second line is drawn branching off of the first Point B, thus suggesting depth.

Figure A

Figure B

b

a

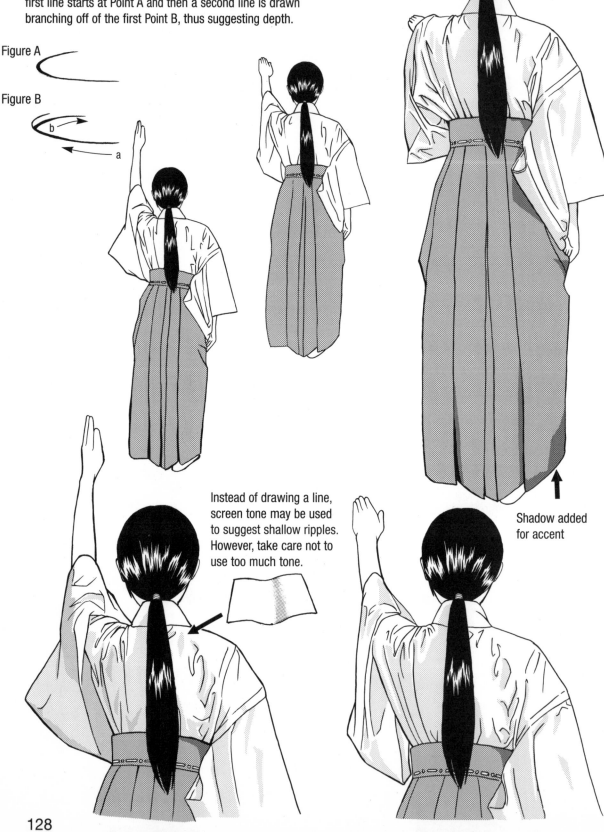

Instead of drawing a line, screen tone may be used to suggest shallow ripples. However, take care not to use too much tone.

Shadow added for accent

One Arm Raised to the Side

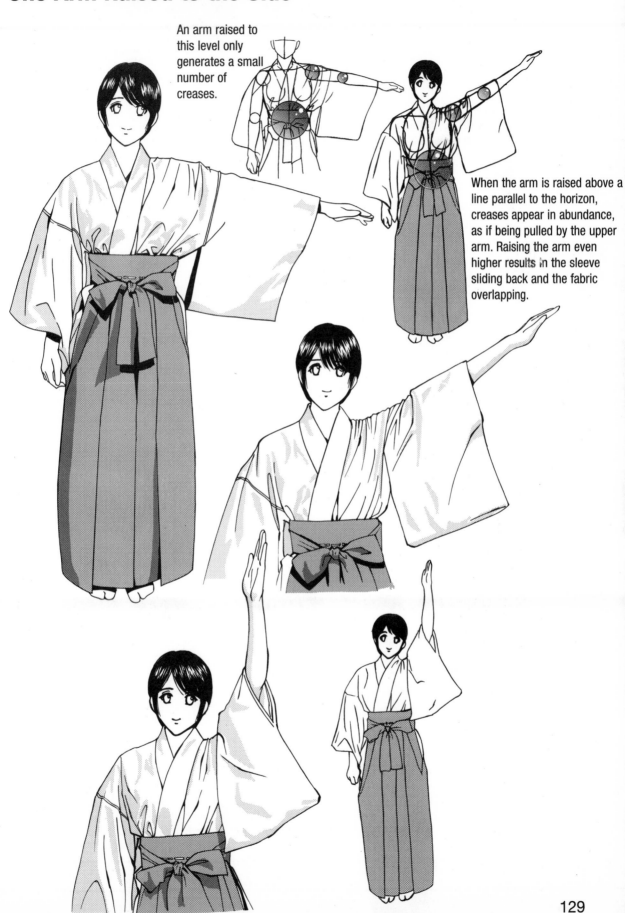

An arm raised to this level only generates a small number of creases.

When the arm is raised above a line parallel to the horizon, creases appear in abundance, as if being pulled by the upper arm. Raising the arm even higher results in the sleeve sliding back and the fabric overlapping.

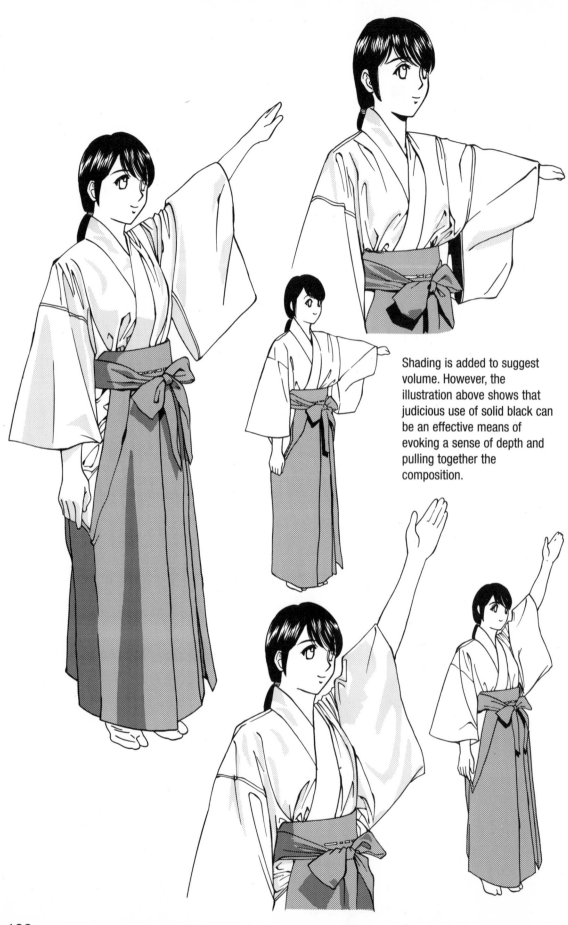

Shading is added to suggest volume. However, the illustration above shows that judicious use of solid black can be an effective means of evoking a sense of depth and pulling together the composition.

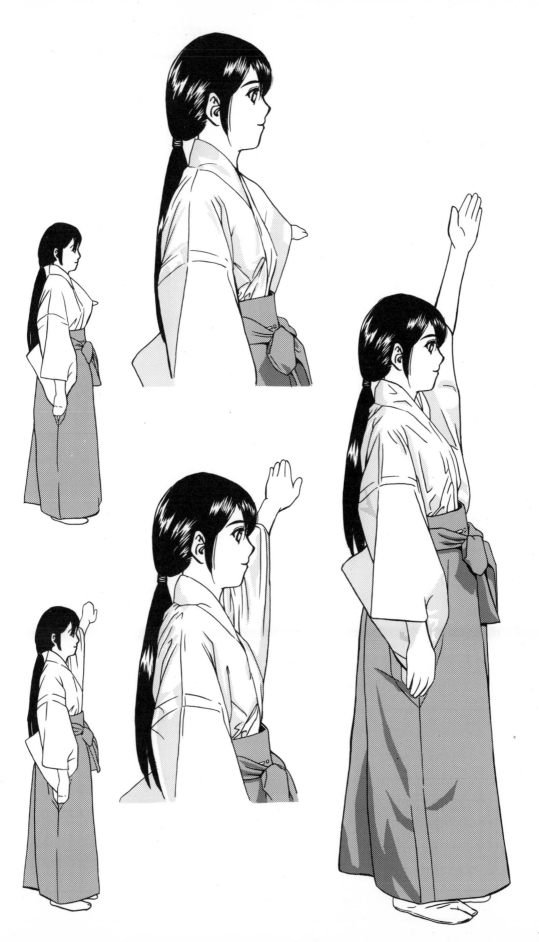

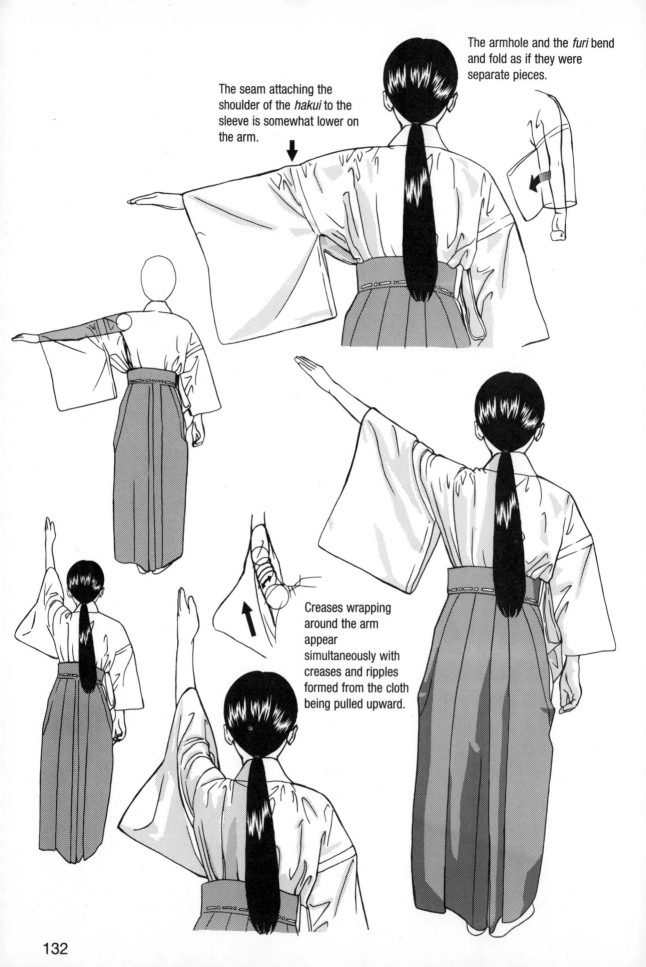

The seam attaching the shoulder of the *hakui* to the sleeve is somewhat lower on the arm.

The armhole and the *furi* bend and fold as if they were separate pieces.

Creases wrapping around the arm appear simultaneously with creases and ripples formed from the cloth being pulled upward.

The key to a pleasing composition is to draw skillfully those areas that give the image volume. Look at the creases encircling the upper arm in the illustration below for reference. Take careful note that if the crease lines are not drawn in a coherent and corresponding flow, the composition will appear clumsily rendered.

There are cascading ripples down from just below the wrist. These are undulations in the cloth that curve downward when it is suspended lightly from both the right and left, and also form when the fabric hangs from one side.

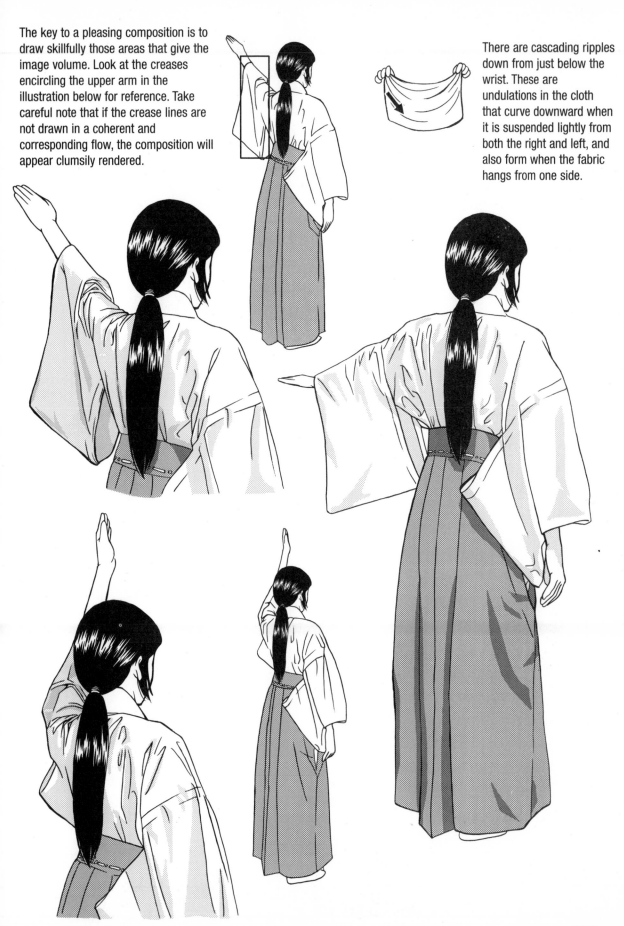

The Arms Crossed

This shadow formed from the seam retaining a crease from when the garment was folded. Omit lines and shadows according to your personal style when creating your own drawing.

Holding a Broom

The image of a *miko* holding a broom is so common, it is indispensable. For a classic pose, draw the broom on the large side when showing the *miko* leaning against it.

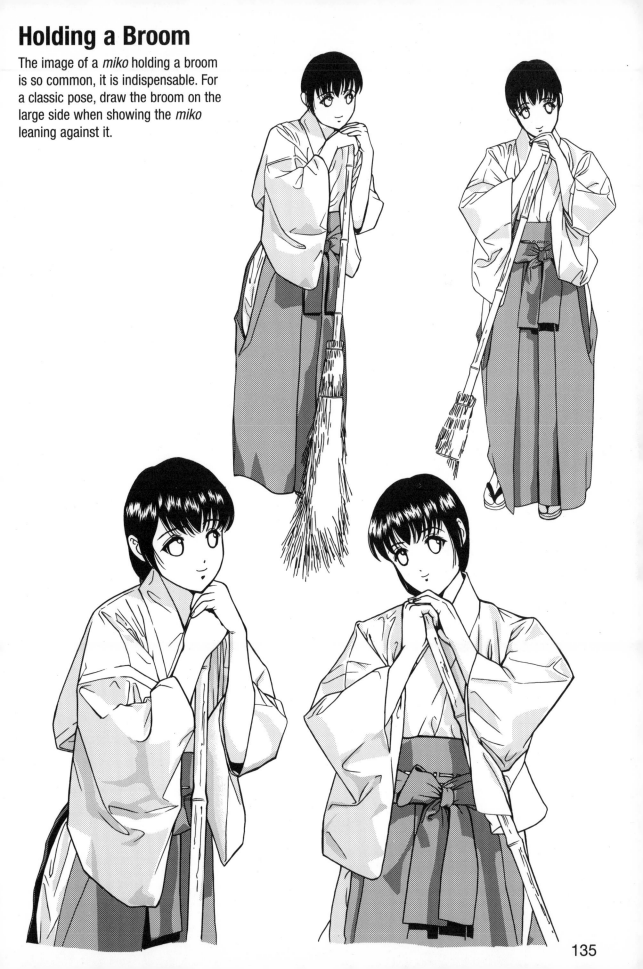

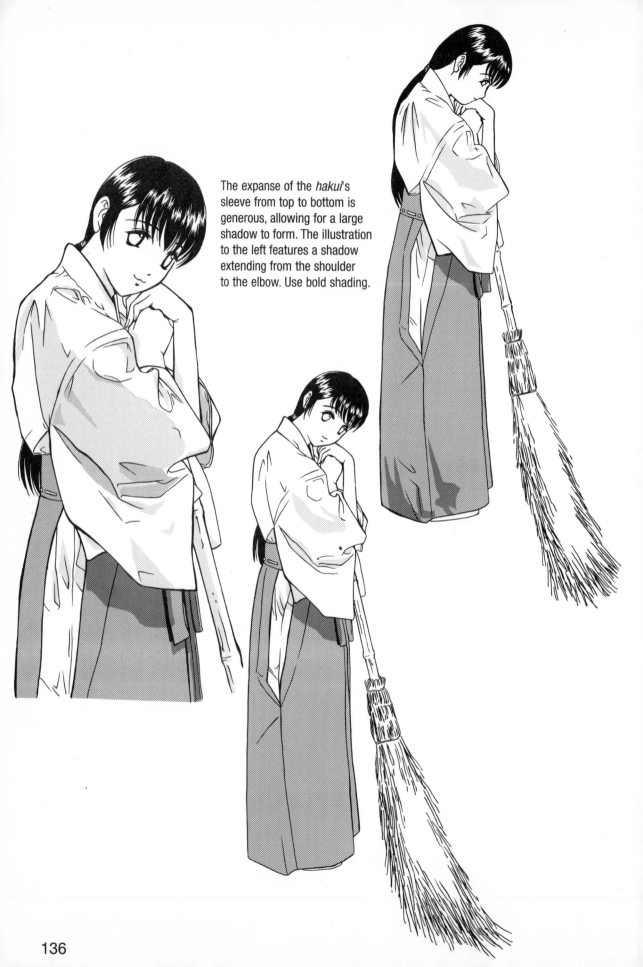

The expanse of the *hakui*'s
sleeve from top to bottom is
generous, allowing for a large
shadow to form. The illustration
to the left features a shadow
extending from the shoulder
to the elbow. Use bold shading.

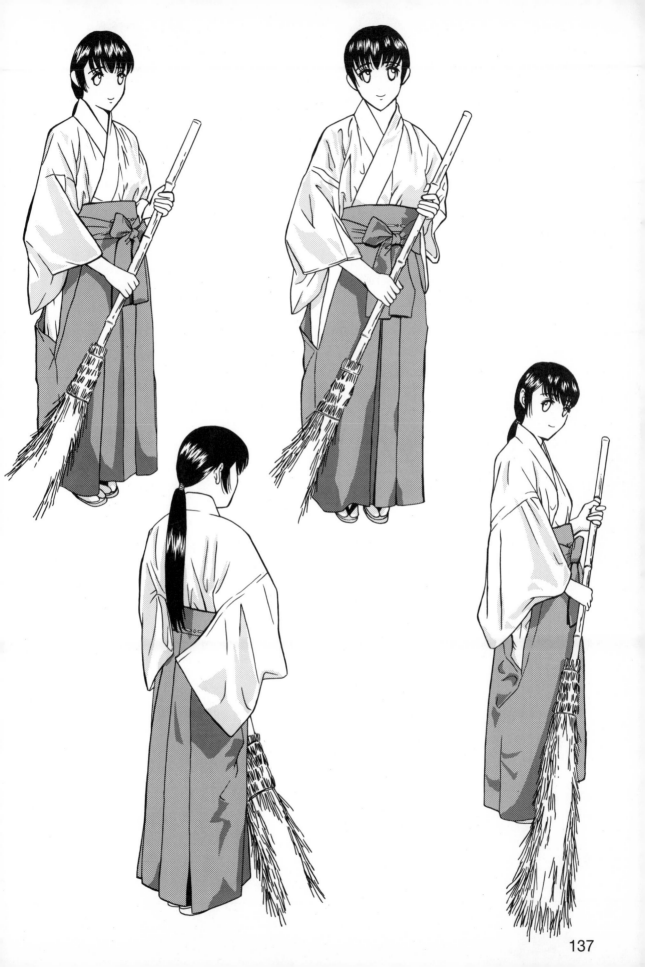

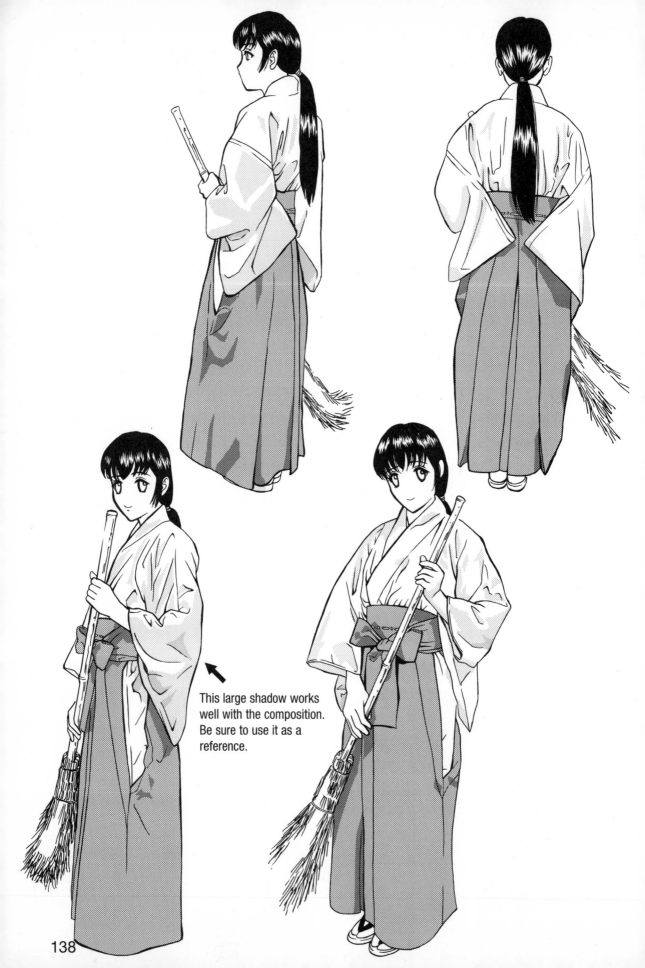

This large shadow works
well with the composition.
Be sure to use it as a
reference.

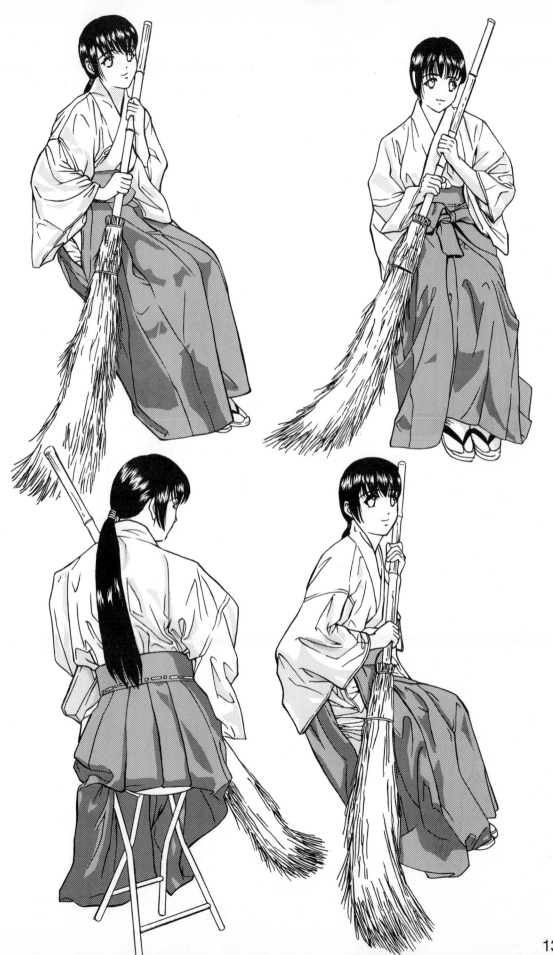

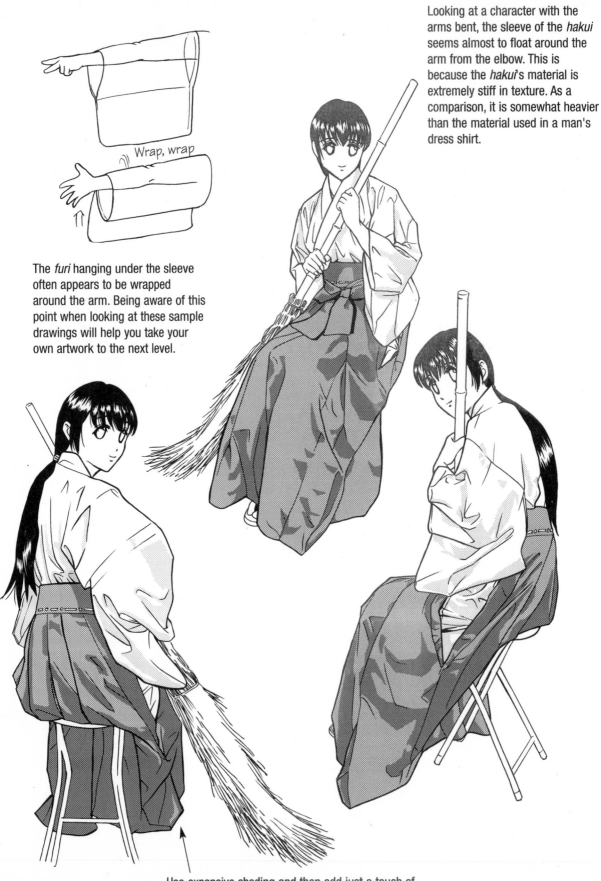

Looking at a character with the arms bent, the sleeve of the *hakui* seems almost to float around the arm from the elbow. This is because the *hakui*'s material is extremely stiff in texture. As a comparison, it is somewhat heavier than the material used in a man's dress shirt.

Wrap, wrap

The *furi* hanging under the sleeve often appears to be wrapped around the arm. Being aware of this point when looking at these sample drawings will help you take your own artwork to the next level.

Use expansive shading and then add just a touch of highlight. Add darker shading if the result appears flat.

Sitting *Seiza*-style (Legs Tucked Underneath)

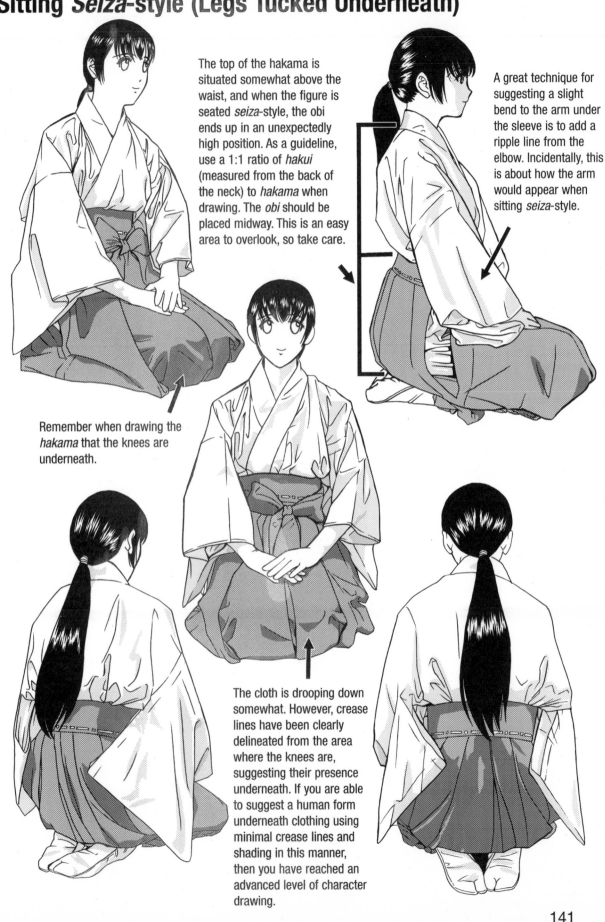

The top of the hakama is situated somewhat above the waist, and when the figure is seated *seiza*-style, the obi ends up in an unexpectedly high position. As a guideline, use a 1:1 ratio of *hakui* (measured from the back of the neck) to *hakama* when drawing. The *obi* should be placed midway. This is an easy area to overlook, so take care.

A great technique for suggesting a slight bend to the arm under the sleeve is to add a ripple line from the elbow. Incidentally, this is about how the arm would appear when sitting *seiza*-style.

Remember when drawing the *hakama* that the knees are underneath.

The cloth is drooping down somewhat. However, crease lines have been clearly delineated from the area where the knees are, suggesting their presence underneath. If you are able to suggest a human form underneath clothing using minimal crease lines and shading in this manner, then you have reached an advanced level of character drawing.

Bowing While Seated *Seiza*-style

The shoulders shift forward and back, albeit slightly. When the chest is puffed out and the character is leaning back, then the shoulders roll back. Conversely, when the back is slumped and the character bends forward, then the shoulders roll toward the front.

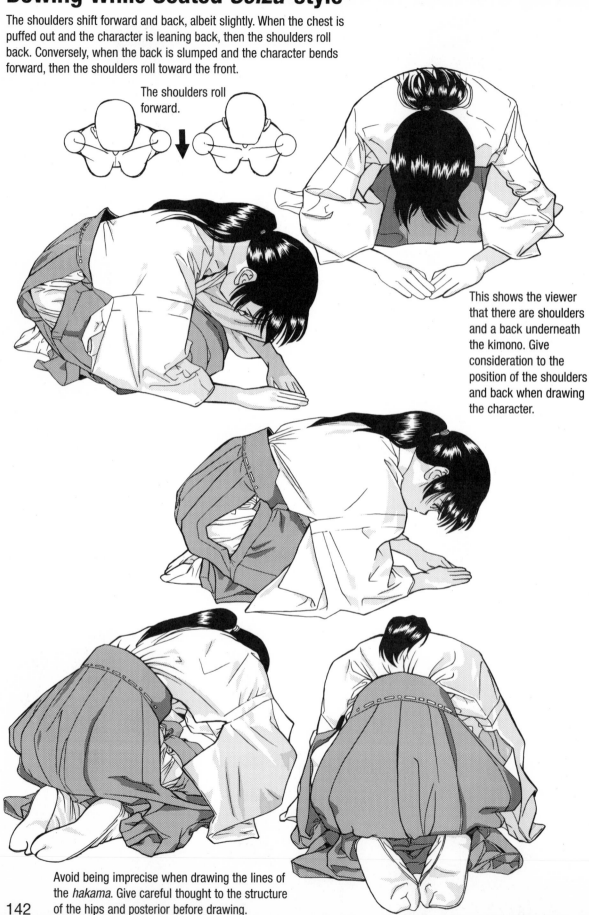

The shoulders roll forward.

This shows the viewer that there are shoulders and a back underneath the kimono. Give consideration to the position of the shoulders and back when drawing the character.

Avoid being imprecise when drawing the lines of the *hakama*. Give careful thought to the structure of the hips and posterior before drawing.

Sitting with Legs Tucked to the Side

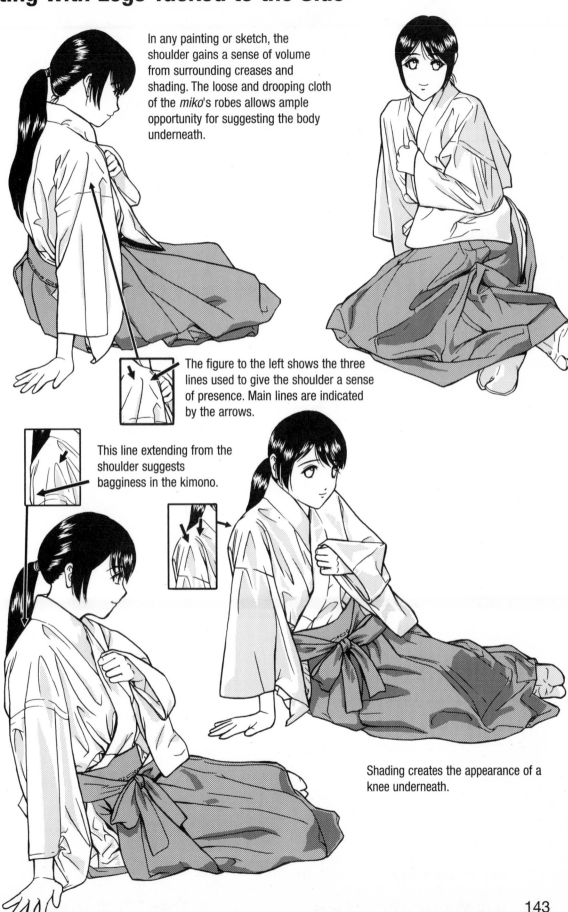

In any painting or sketch, the shoulder gains a sense of volume from surrounding creases and shading. The loose and drooping cloth of the *miko*'s robes allows ample opportunity for suggesting the body underneath.

The figure to the left shows the three lines used to give the shoulder a sense of presence. Main lines are indicated by the arrows.

This line extending from the shoulder suggests bagginess in the kimono.

Shading creates the appearance of a knee underneath.

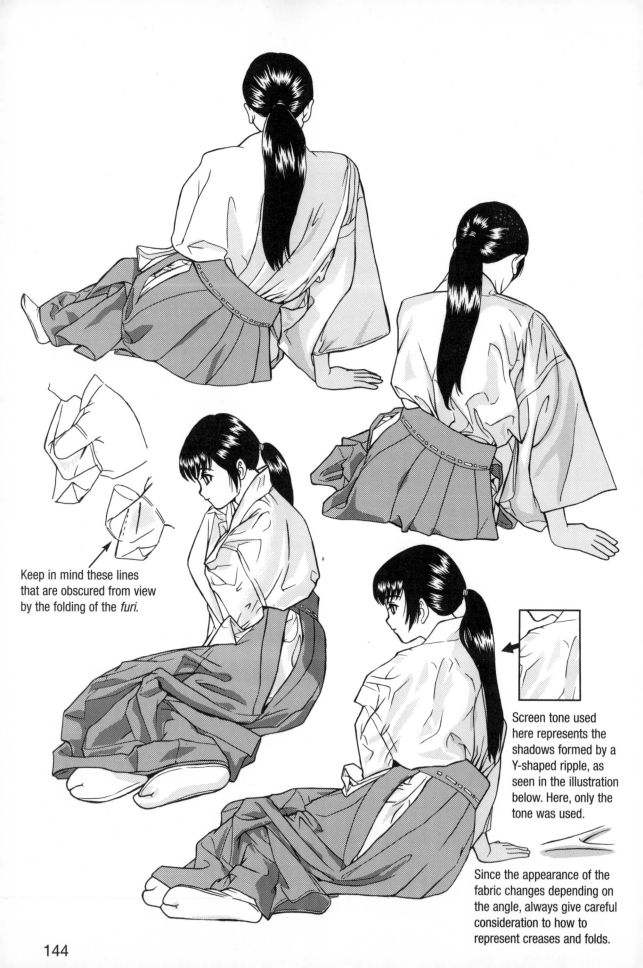

Keep in mind these lines
that are obscured from view
by the folding of the *furi*.

Screen tone used
here represents the
shadows formed by a
Y-shaped ripple, as
seen in the illustration
below. Here, only the
tone was used.

Since the appearance of the
fabric changes depending on
the angle, always give careful
consideration to how to
represent creases and folds.

Reclining

A scene of a *miko* sleeping in her robes is unusual and rarely represented. Nevertheless, here are some sample illustrations for reference.

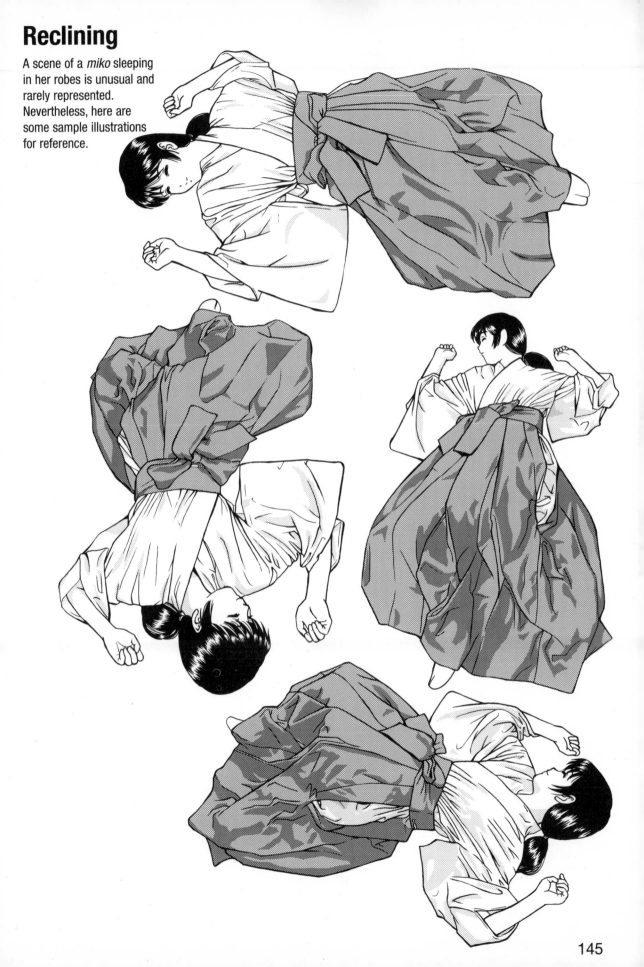

It is difficult to visualize how the loose skirt of the *hibakama* (red *hakama*) will appear on a sleeping figure. Use the samples offered in this book as reference.

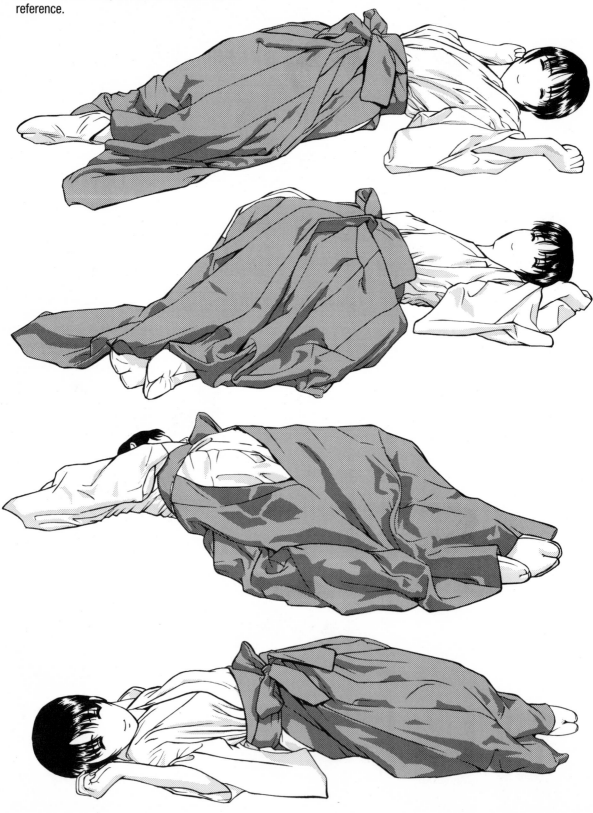

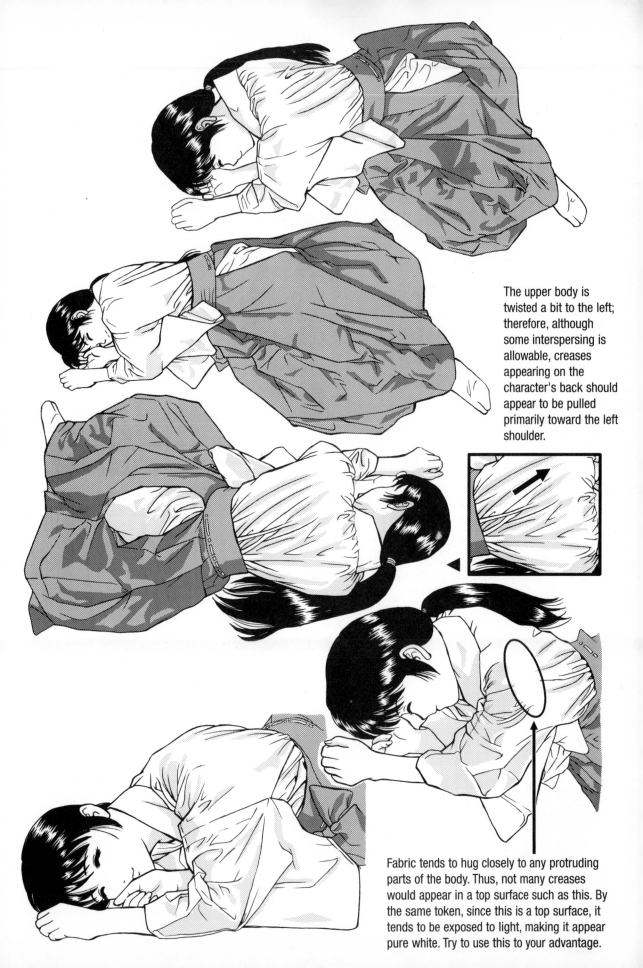

The upper body is twisted a bit to the left; therefore, although some interspersing is allowable, creases appearing on the character's back should appear to be pulled primarily toward the left shoulder.

Fabric tends to hug closely to any protruding parts of the body. Thus, not many creases would appear in a top surface such as this. By the same token, since this is a top surface, it tends to be exposed to light, making it appear pure white. Try to use this to your advantage.

The *hakama* is not an article that fits snugly against the body. Consequently, the fabric tends to rumple and shift at will depending on the character's position, taking on forms beyond what the artist generally anticipates. This makes it difficult to draw. Rather than taking on the impossible task of rendering every wrinkle possible, just draw them in a convincing way. To achieve this, first produce a rough sketch of the figure. Then add creases and ripples of fabric along the body's contours. Strategically place key lines such as seams and folds, and simply add the rest wherever it seems appropriate.

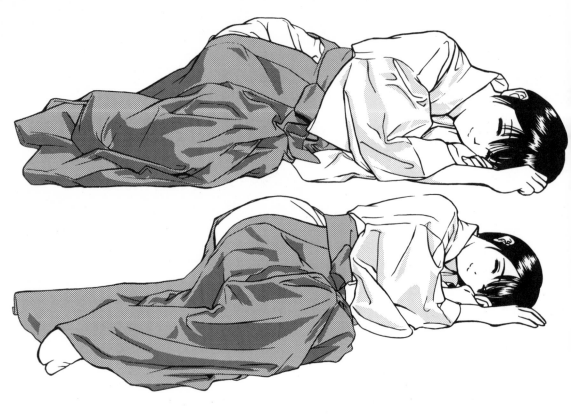

The key here is giving rounded edges to the folds.

Have seams and folds follow the curves of the body.

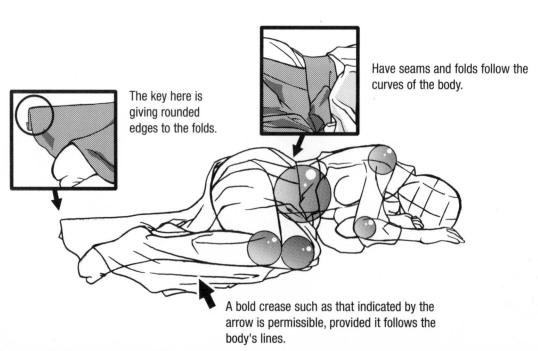

A bold crease such as that indicated by the arrow is permissible, provided it follows the body's lines.

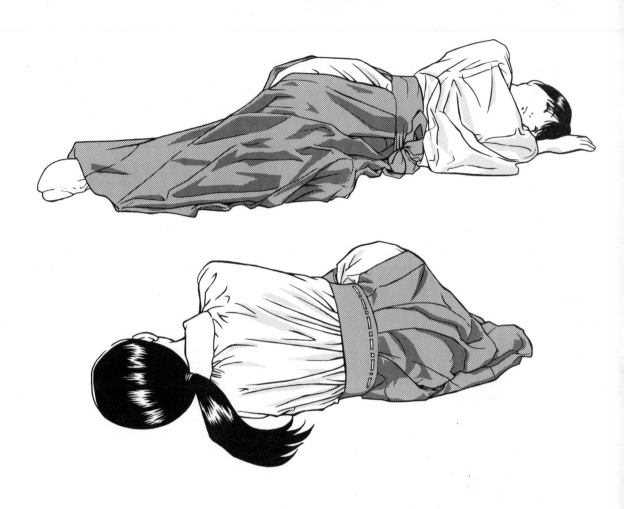

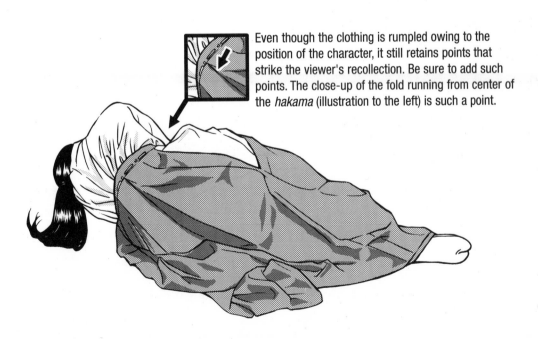

Even though the clothing is rumpled owing to the position of the character, it still retains points that strike the viewer's recollection. Be sure to add such points. The close-up of the fold running from center of the *hakama* (illustration to the left) is such a point.

HOW TO DRAW
MANGA
THE WEBSITE

Official books

Starter kits

Pens and nibs

Copic markers

Tones and tools

Instructional videos

Japanese manga paper

Artists' bulletin board

www.howtodrawmanga.com

Your official source for authentic Japanese manga supplies

To master the art of manga, you need the proper tools.
But you don't have to travel all the way to Japan to find them.
Shop online at www.howtodrawmanga.com. It's where the pros go.

2-8-102 NAKA-CHO, KAWAGUCHI-SHI, SAITAMA 332-0022 JAPAN ● PHONE/FAX +81-48-259-3444 ● EMAIL sales@japanime.com

Guaranteed Worldwide Delivery
FedEx. ✑EMS

We Accept All Major Credit Cards

Secure Online Shopping
epubliceye.com
Certified safer site